MARTYN TAYLOR

BURY ST EDMUNDS
THROUGH TIME
REVISITED

AMBERLEY

Acknowledgements

Joe Wakerley owned the Bury Bookshop in Hatter Street and was an avid collector of postcards of Bury St Edmunds and the surrounding area. He was always liberal with his collection by making the cards available to others. Following on from his sad death in 2006, I was approached by his son Tim and daughter Jo to see if I could use some of this amazing collection and bring them to a wider audience. It is the family's generosity that has enabled this book to proceed. As ever nothing would have been achieved without the invaluable help of my wife Sandie.

★ FOUR FLOORS OF BOOKS
★ FAST ORDERING SERVICE
★ TELEPHONE ORDERS WELCOME
★ SECONDHAND BOOKS BOUGHT AND SOLD
also GREETINGS and XMAS CARDS, GIFTWRAP,
 STORY TAPES.

We have thousands of books in stock with new titles arriving every week. We have books to suit every taste and every pocket. Do come and visit us to browse through our full range.

If you are not sure exactly what to give someone as a gift, we are always happy to advise and usually will be able to order any book you require which is not in stock.

Make the most of your local bookshop - you will be amazed at how much we can offer.

THE BURY BOOKSHOP
28/28A Hatter Street,
Bury St. Edmunds, Suffolk.
Tel: (0284) 703107

First published 2023

Amberley Publishing
The Hill, Stroud, Gloucestershire, GL5 4EP
www.amberley-books.com

Copyright © Martyn Taylor, 2023

The right of Martyn Taylor to be identified as the Author of this work has been asserted in accordance with the Copyrights, Designs and Patents Act 1988.

ISBN 978 1 3981 0930 8 (print)
ISBN 978 1 3981 0931 5 (ebook)

British Library Cataloguing in Publication Data.
A catalogue record for this book is available from the British Library.

Origination by Amberley Publishing.
Printed in the UK.

Introduction

In 1894, postcards were able to have photographs imprinted on them, which gave greater scope to the many companies that produced these. Not only could the sender stay connected with relatives and friends, but these postcard images could enable them to appreciate the environment they were in. Some of the national postcard manufacturers such as Valentines, Farringdon, Raphael Tuck, and Homeland produced millions, whilst local companies such as Pawseys, Cousins, Cornish, and Drew Imperial Studios published scenes of Bury St Edmunds, which were obviously very popular. Apocryphally the most common message sent was 'wish you were here'. The heyday of the postcard was the first two decades of the twentieth century. Collecting postcards is still very popular and collectors tend to focus on a particular subject. In the USA, collectors are called deltiologists. Applying the same method from my first book for Amberley, *Bury St Edmunds Through Time*, a then and now concept, this is what this book sets out to achieve, only now using postcards. To take a comparable 'modern day' photograph is virtually impossible without vehicles either parked or travelling in the way of the camera, something we have to live with. A very interesting consequence of the COVID-19 pandemic lockdown was that the streets were devoid of people, which in some cases strangely added to the modern-day photographs.

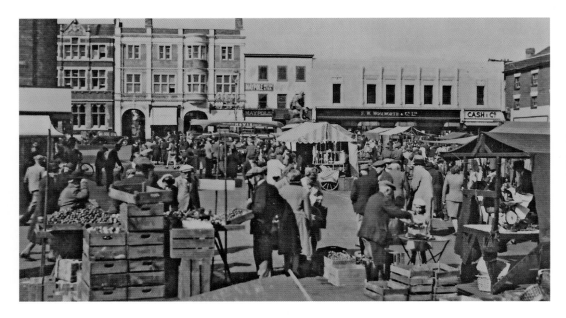

Cornhill on Market Day
Looking across to the west side of a bustling Cornhill, Maypole, once one of Britain's biggest employers, promoted margarine as an alternative to butter. The company was absorbed by Allied Supplies in 1964, with the last Maypole shop closing in 1970. Dear 'old Woolies' has also gone, finishing in 2008. The Post Office aside Market Thoroughfare, aka Bell Arcade, would close in 2016, moving into WHSmith next door, and in September 2020, Barnes Construction commenced shoring up the façade to create a wider arcade. COVID-19 regulations saw many market traders absent in 2020–22.

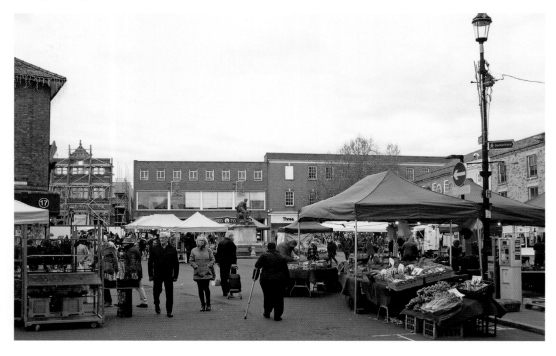

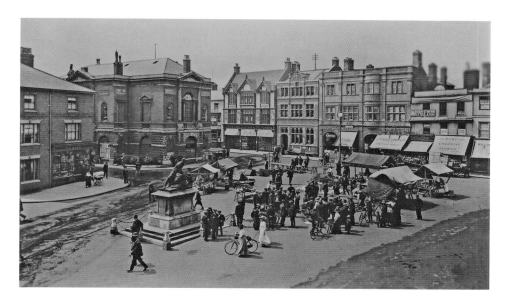

Cornhill from Moyses Hall

A comparable photograph taken from Moyses Hall's second-floor office. Seen on the left is Walter George King's brush manufacturers shop until Croasdale & Sons Ltd chemists took it on during the 1920s. They are still trading here. The Market Cross is a constant feature, as is the South African War memorial, but to the west major business changes have occurred. Stead & Simpson, Liptons, Maypole, and Colonial Stores have all gone but, as previously stated, the rebuilding of the Post Office is a major project, scaffolding supporting its Victorian façade for future use.

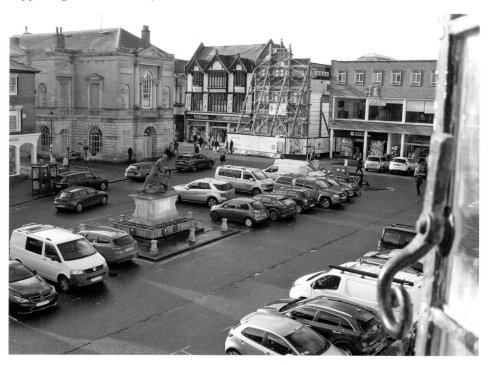

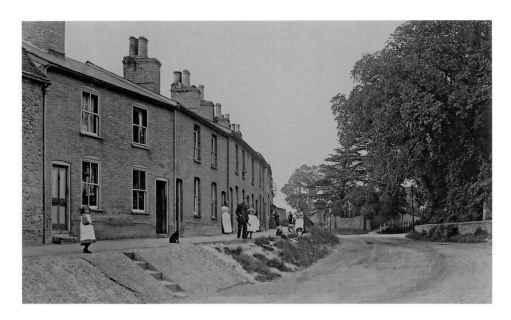

Out Eastgate

St Edmunds Terrace is up on the bank leading to the forked junction. Hollow Road on the left leads to the Sugar Beet Factory, which has vastly expanded from its beginning in 1925. Barton Road is to the right. Straddling this fork are the ruins of St Nicholas medieval hospital, founded by Abbot Hugh II (1215–29). The ornate tracery window was taken from St Petronilla, another medieval hospital once in Southgate Street; demolished in 1818, the culprit was Philip Bennet Esq of Rougham. The postcard's stamp is franked August 1907, but the scene has changed little except that it is no longer called Out Eastgate.

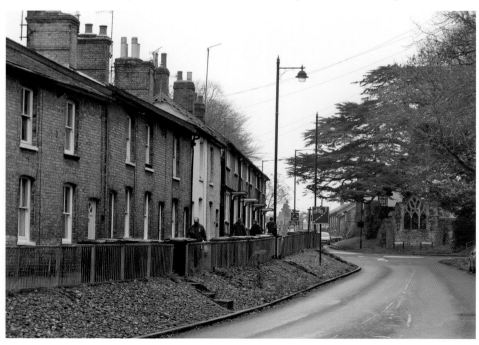

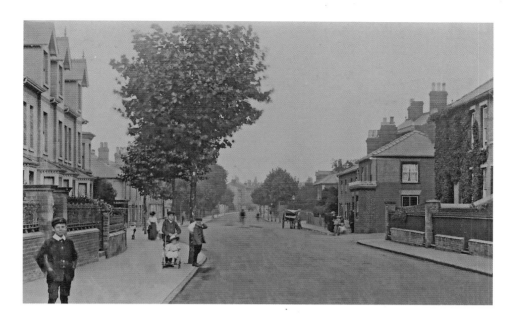

Out Risbygate

On the left are fine three-storey houses, including Euston House and Chelsea House, built between 1900 and 1902 by a London builder who lived in Euston and his sister in Chelsea – voila! On the right-hand corner of Victoria Street is the Falcon Inn, which opened in 1869. Harry Green was landlord around the time this photograph was taken, in 1915. Note the porch, now gone. The Falcon sadly closed in 2012 and is now residential. Also closed (mid-twentieth century) is a private school for young children on the opposite corner at No. 1 St Georges Terrace, Out Risbygate, which was run by three sisters, Misses Florrie, Gurtie, and Nellie Smith.

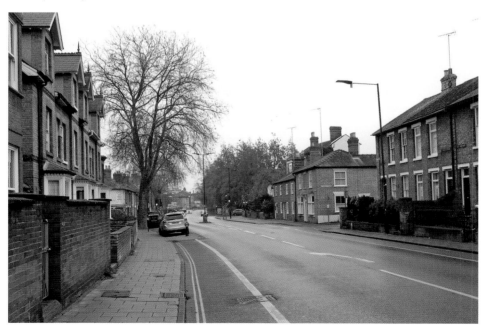

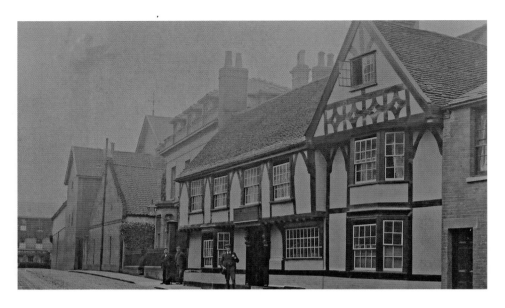

Dog & Partridge, Crown Street

Known in earlier years as the Mermaid Inn, Greene King acquired this popular pub in 1872. In days gone by Theatre Royal patrons attending a late performance could enjoy a speciality of the pub, Rook Pie! The pseudo-Jacobean timbers have been removed whilst internally, more open-space dining areas now prevail. Fortunately, the iconic pub sign has been retained, saved from being changed to a Pub & Flame Grill sign. The modern-day photograph has people looking at the Abbot Reeve plaque, put up in 1907 to commemorate where his house was, but in the sepia photograph it is absent.

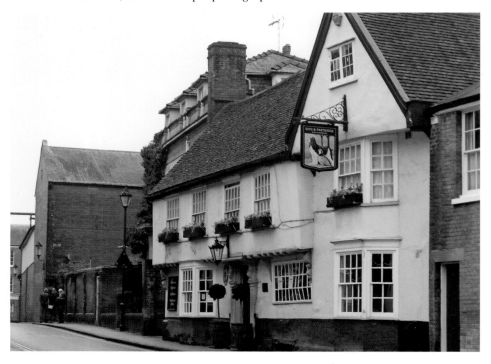

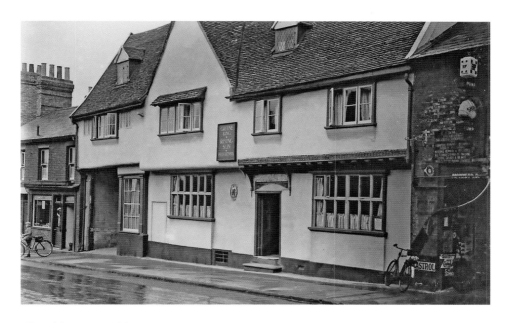

The Rising Sun, Risbygate Street

According to records, this popular inn was serving beer from at least 1727, making it one of the town's oldest. 'Mine hosts' the Barnard family's tenure was from 1904 until 1976, meaning they were probably the landlords when this photograph was taken. This ancient inn was converted to a 'gastro-pub', the St Edmunds Tavern, in 2011 for a short while, a tremendous loss to real pub devotees. Part of the property became Peatlings Wines briefly, then became Casa Del Mar restaurant, then Casa. The adjacent premises were once Wells Pet Shop, then Anglia Arms, and is now the E-CIG Vape Café.

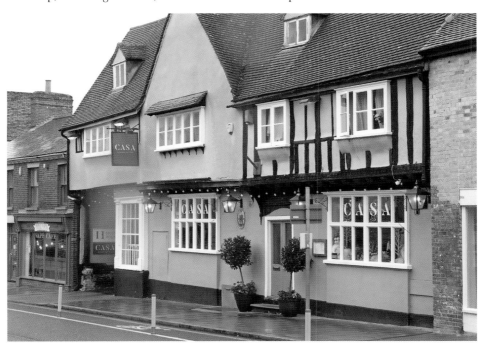

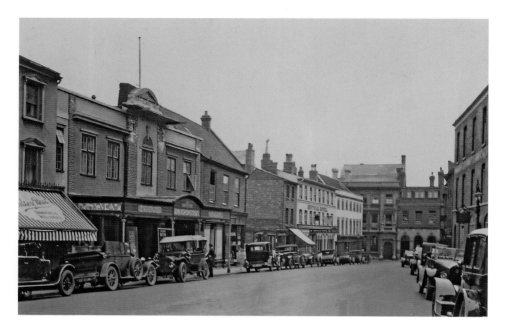

Buttermarket Looking South

The Playhouse cinema on closing became the Co-op Quality House store, then Argos until 2017. It is now The Cambridge Building Society. Further along at No. 34 is the pseudo-Jacobean façade of the Card Factory, once Freeman Hardy & Willis shoe shop. On the sepia photograph, it is shown as a gap after a 1915 Zeppelin bomb destroyed the properties there. This gap, near the awning, was still evident after the Second World War. Further along is the Suffolk Hotel, which closed in 1996, divided into Ottakars/ Waterstones and Edinburgh Woolen Mills adjacent. In the far distance is the Midland Bank, which became HSBC in 1992.

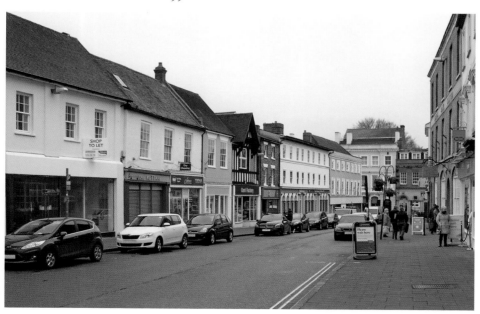

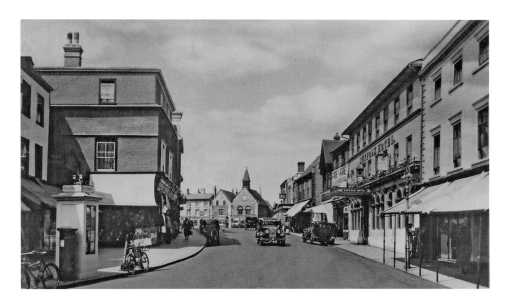

Buttermarket Looking North

On the corner with Abbeygate Street, Plumptons traded in ladies' fashions and haberdashery until 1961, Palmers taking over until closing in 2018. Also gone is the Trust House Forte Suffolk Hotel, a favourite watering hole of Bury. It closed in 1996, then divided into two shops; applications to revert back to a hotel have been submitted. On the right, the Playhouse cinema closed in 1959, becoming retail premises. Further up is Moyses Hall, the Borough Museum, the clock of which is obscured now by a large plane tree. On the left is a Tardis-looking K1 mk234 telephone kiosk, installed in small numbers from 1921 by the GPO.

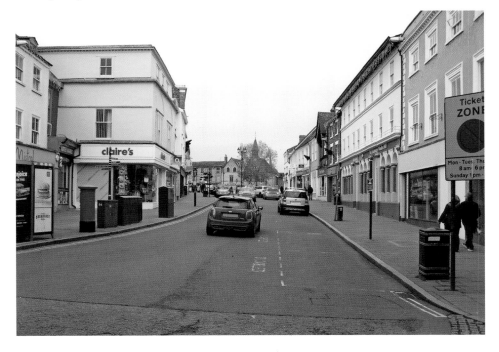

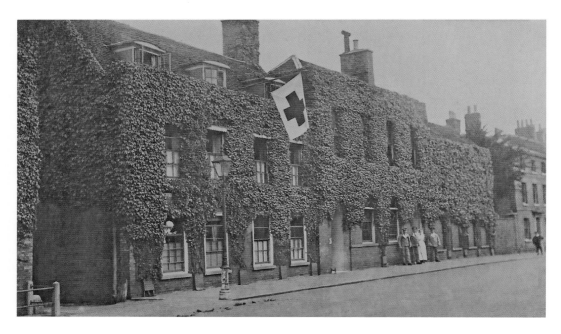

Red Cross Hospital, No. 113 Northgate Street

Known as Manchester House, this Grade II* property, on the corner of Cotton Lane, was the surgery of physician Sir Thomas Gery Cullum, the 7th Baronet of Hardwick. It was in his ownership with his wife, Lady Mary, from 1790 until his death in 1831. It became a Red Cross hospital from 1916 until 1923, attending to casualties from the First World War. In the photograph with a nurse are three patients wearing unsurprisingly 'Hospital Blue' garb. Denuded of creeper now, it shows off the Suffolk white bricks. The hanging sign reads 1840, possibly when popular local builder William Steggles refronted the building.

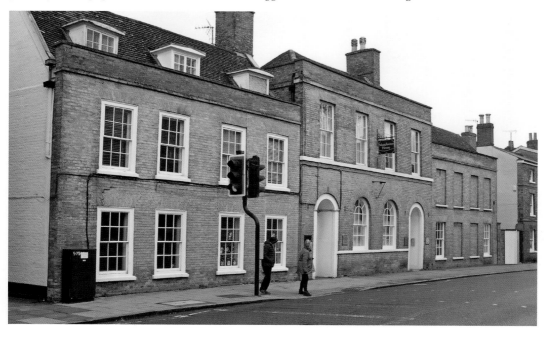

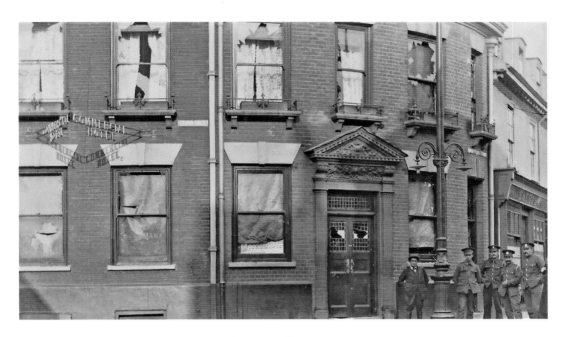

Griffin Damaged, Cornhill Corner/Brentgovel Street

The Ipswich Tollemache Cobbold Brewery at one time owned the Griffin Hotel. Architect John Shewell Corder designed the portico on the corner in 1898. After the First World War broke out, 1915 saw anti-German feelings running high in the town. Despite protestations by landlord Theodore Jacobus that he was British, his windows were broken by rioters, who took a while to disperse. William Sneezum's adjacent butchers (today Kitchen Kave) were unaffected. The Griffin closed in October 1982 and the premises became different units until unified to form the Edmundo Lounge Café Bar.

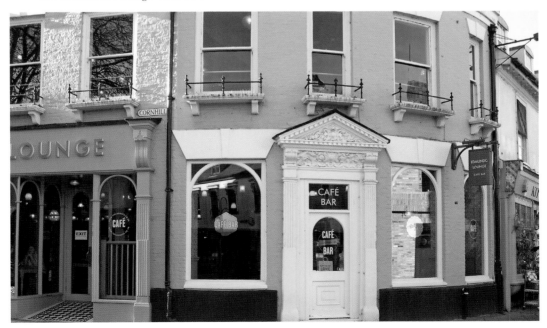

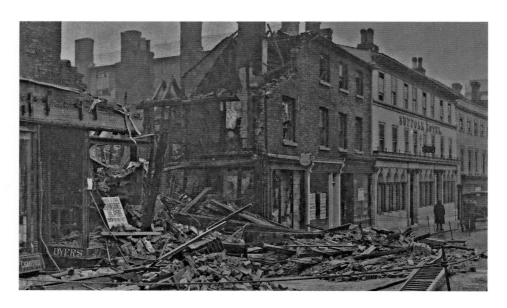

No. 34 Buttermarket Zeppelin Raid

Nos 30–34 Buttermarket were subjected to a devastating bomb raid by a German Zeppelin airship in 1915. Destroyed were the premises of Clarkes tobacconists, Johnson Brothers Dry Cleaners, Days Boot-Shop, and Ellen Wise Ladies Outfitters. Fortunately, no one was injured, though sadly Ellen Wise's collie dog was killed. Once the premises of cycle shop owner Thomas Henry Nice, No. 34, remained barren until being built on in the 1950s. The new pseudo-Jacobean property eventually became a branch of national shoe retailers Freeman Hardy & Willis until it ceased trading in 1998.

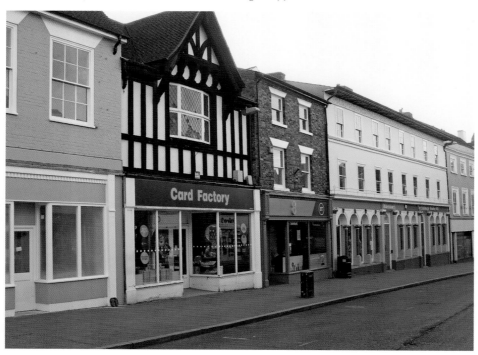

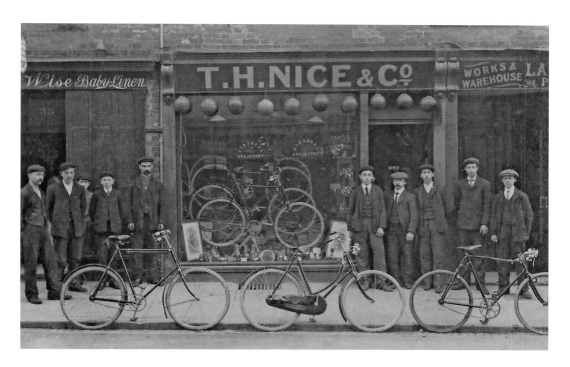

T. H. Nice & Co. Ltd, No. 34 Buttermarket

Thomas Henry Nice advertised as a cycle maker before the First World War, selling this very popular mode of transport. Note the very low handlebars on the 'racing bike' on the right. His shop and other adjacent shops, as previously stated, were severely damaged by a Zeppelin raid on 30 April 1915. Thomas Henry Nice then relocated his business temporarily to St Johns Street, eventually moving it to No. 21 Abbeygate Street (now the Giggling Squid restaurant). Here, Nice conducted a motor car business, petrol pumps still evident in the late 1950s and early 1960s.

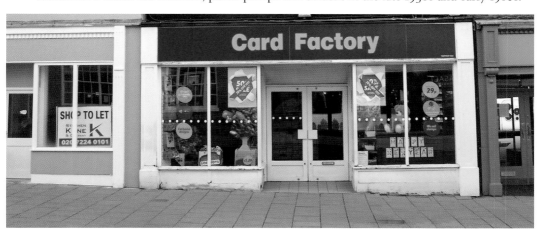

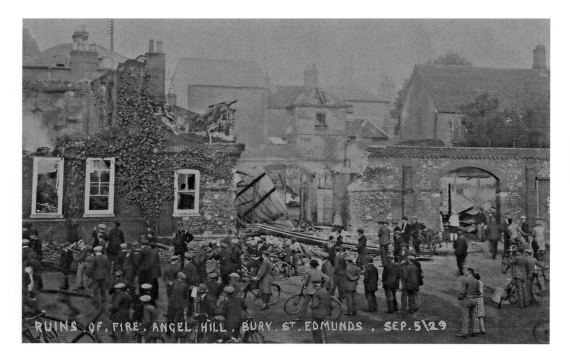

RUINS OF FIRE. ANGEL HILL, BURY. ST. EDMUNDS. SEP. 5\29

No. 7 Angel Hill Fire

On 5 September 1929, a fire, probably caused by an electrical fault, engulfed automotive engineer Rowland Todd's house. Tragically, his young son Trevor died. Bury Corporation purchased the site in 1935 for municipal offices and to designs by architects Bill Mitchell and Basil Oliver. The offices, complete with a grand marble staircase, opened on 9 April 1937. With the building of West Suffolk House in Western Way the St Edmundsbury Council moved in April 2009. Subsequently, Bury Town Council moved into No. 7 Angel Hill and in June 2020 relocated to the Guildhall Council chamber.

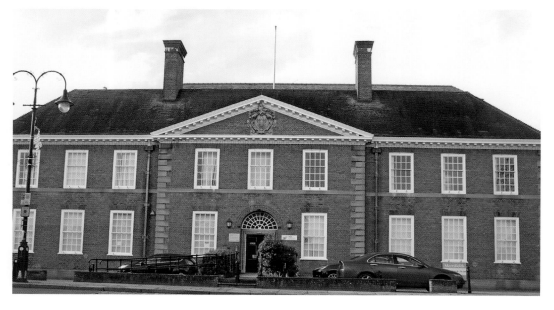

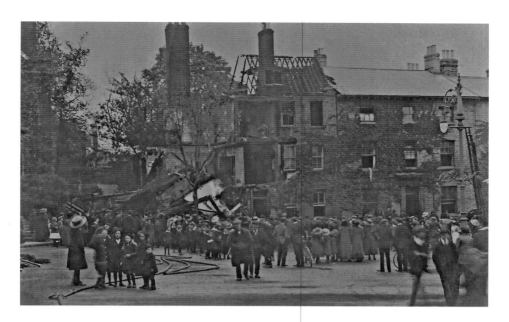

Angel Hill Fire Looking North

On 14 May 1912, No. 9 Angel Hill was destroyed by fire, as can be seen in this Farringdon Studio postcard (the cause unknown). The fire spread to the adjoining No. 10, part of which was damaged and rebuilt. According to White's Directory of 1890/1, a Ms Catherine Allen was running a ladies' boarding school from No. 9. For many years a large open space remained until a few years ago, when a sympathetic extension was added to No. 10, a small gap still evident between the extension and Angel Corner.

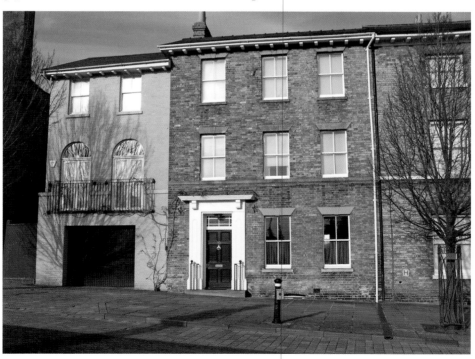

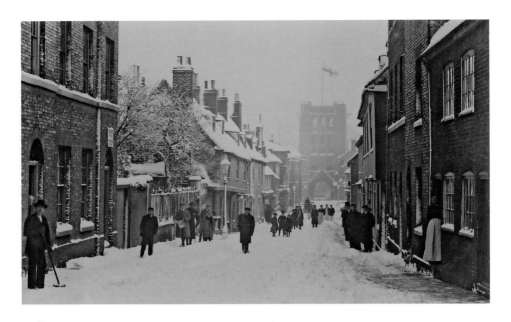

Churchgate Street in the Snow

An almost Lowryesque scene of a busy Churchgate Street. In the distance the civil and state flag of St George of England is flying high on the Norman tower. Whether it is 23 April, St George's Day, is a matter of conjecture, but it is not unheard of for snow to fall that late. The street lamp on the left amidst snow could almost be taken from *The Lion, the Witch and the Wardrobe* by C. S. Lewis. A more modern street lamp can be seen in between the ugly blot on the recent photograph – wheely bins!

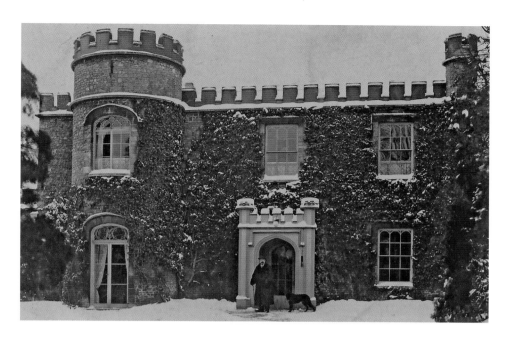

St Andrew's Castle, No. 33 St Andrews Street South

Ezekiel Sparke, attorney to wealthy wool merchant and banker James Oakes, built this 'Gothick' creation, Bury's only castle, at the end of the eighteenth century. It has a stone vaulted ceiling in the reception hall. Industrialist George Boby, who had his family's St Andrew's Works nearby, lived here from 1865 to 1890, when he died. 1929 saw the sisters of St Louis open a convent school at the castle, gaining grammar school status in 1958 and becoming a state-run Catholic school in 1971, before closing in 2013. The Active Business Centre opened at the castle in 1990 and are now licenced for weddings here.

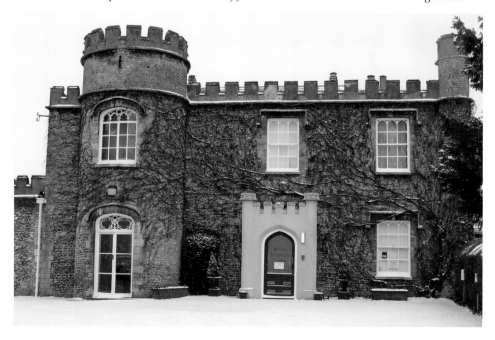

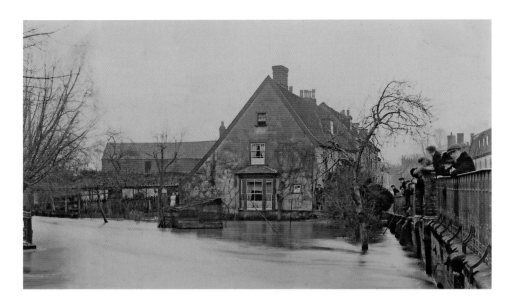

Eastgate Street Flooding

During the latter part of December 1906, heavy snow lay across much of England. The thaw of the snowfall obviously contributed to the River Lark bursting its banks, as this postcard of January 1907 shows. Low-lying areas were affected, especially this former shop at No. 12 Eastgate Street. Torrential rainfall on 15 September 1968 again caused massive flooding throughout the town. In Eastgate Street the fine 1840 Steggles-built bridge was erroneously blamed by not allowing the Lark to flow through. Demolition was advised. Thankfully, the bridge was retained, later listed, and the riverbanks strengthened.

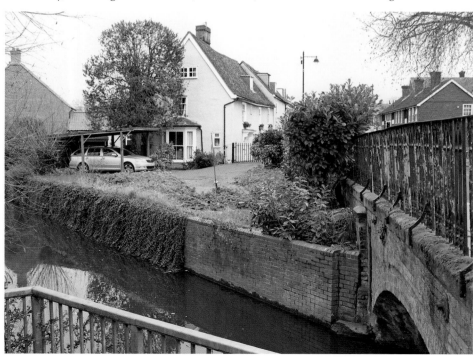

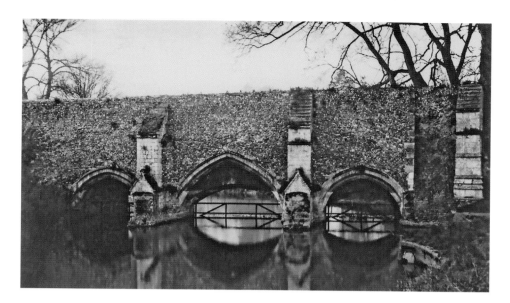

Abbots Bridge Facing West

This iconic bridge, a survivor of the early thirteenth century, is Grade I listed. Once planks were laid between the open buttresses, thus allowing people to cross the River Lark over to the Vinefields. Inside the abbey the monks could travel over the bridge without hinderance Note the high level of the river in the sepia photograph and a 'safety' railing of some kind on the Abbey Gardens side. This railing corresponded to an iron grating similar to a portcullis used to stop any undesirables coming upriver. Very little has changed after all the years.

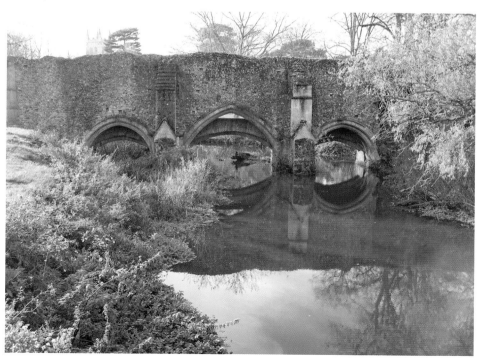

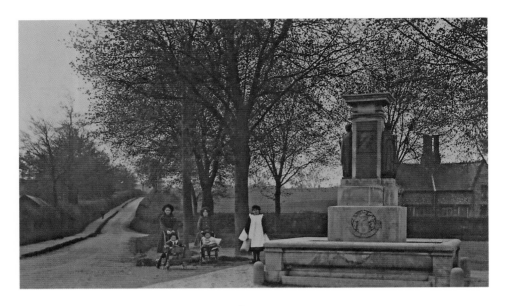

Ouida Memorial Looking Up Vinery Road

No more than a track, Vinery Road in 1920 led to the Cullum-owned Hardwick, now the site of the West Suffolk Hospital. Ouida was the pen name of Bury-born popular Victorian author Louise de la Ramee, a spendthrift and animal lover. She disassociated herself with England and moved to Italy, dying there in abject poverty in 1908. The same year, *Daily Mirror* readers donated money for this horse trough unveiled in 1910 by George Gery Cullum. To the right of the memorial is a Cullum family 'Y-shape cottage', which was demolished in the early 1960s for the nearby Stamford Court shopping precinct.

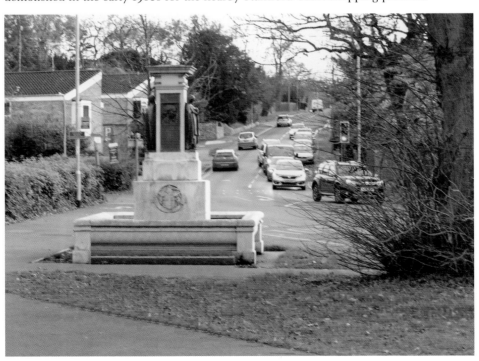

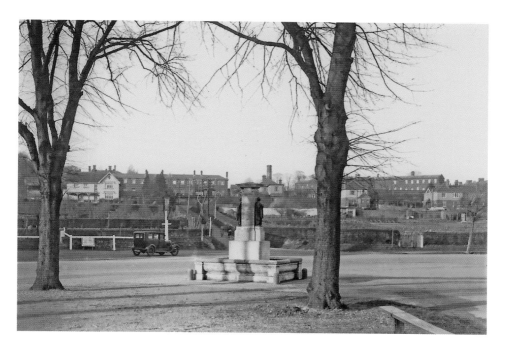

Ouida Memorial Looking to Petticoat Lane

In the foreground is the Spread Eagle pub, mentioned in Payne's 1833 survey of the town. Unfortunately, the pub's bowling green is now a car park. On the opposite corner, during the Second World War, stood a pillbox and mortar emplacement. The Green Ace Garage now stands there. Up on the left is the much-named White House. To the right are wings of the Thingoe Union Workhouse from 1835, later to become St Mary's Geriatric Hospital. It closed in 1977 and was demolished. Though the vista is somewhat obscured by trees, the Ouida Memorial has been resited.

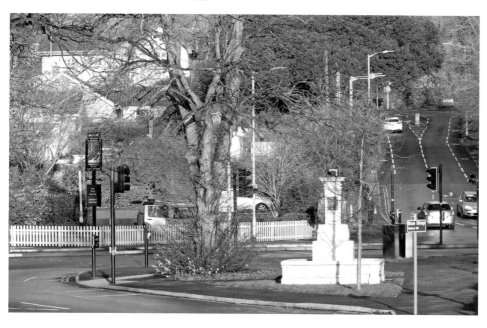

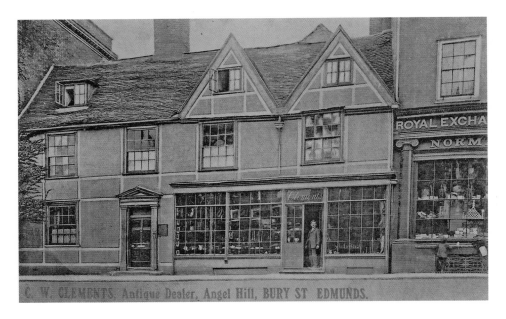

C. W. CLEMENTS, Antique Dealer, Angel Hill, BURY ST EDMUNDS.

No. 4 Angel Hill

A Grade II listed shop with origins from the sixteenth century. This image of around 1910 shows the probable owner, antique dealer Charles Walter Clements, standing in the doorway. After Charles Clements ceased trading, it became Pamela Exclusive Fashions & Furs, which was run by Mrs Clough for many years. In 1997, Geoffrey Stych opened Olivia Benn Ladies Fashions at No. 4 Angel Hill. The business was named after his two children, Olivia and Ben – and why not! Generously, space is given so charity Christmas cards can be sold from here. Adjacent is the chemist shop of Arthur Norman, subsequently Leeson & Burdon and now a coffee shop.

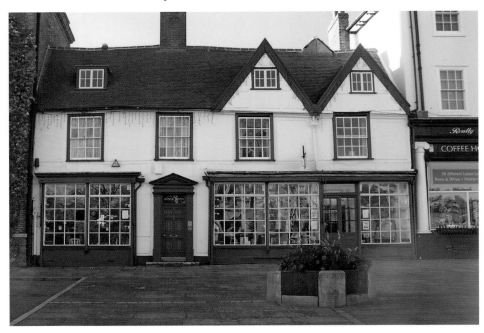

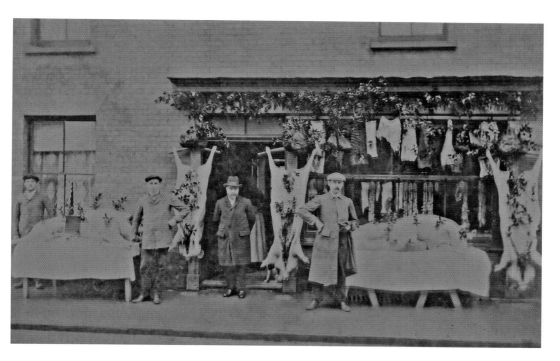

Dixons

William Dixon advertised as a 'High Class Pork Butcher' when he opened his shop in 1896 selling top-quality meat. His sausages became very popular, as did his brawn, also known as pork cheese, a meat jelly made with flesh from a pig's head. Dixons traded until at least 1970 when it was taken over by Barwell's of Abbeygate Street after Chris Lacey had joined his father Maurice, Barwell's owner, in 1965. Eventually, the butchery business at No. 109 Risbygate Street closed and it went on to become an Indian restaurant, Rose of Bengal. This recently rebranded as Spice Garden.

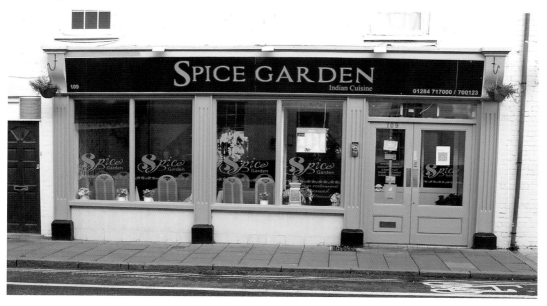

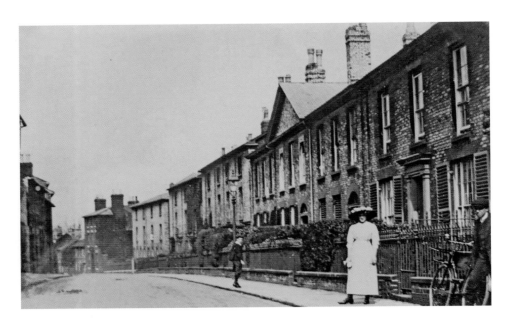

Well Street

The image shows almost all of St John's Terrace, Well Street, labelled as such with set-in stones (very worn) at either end. The terrace is unique in the town. Clearly conceived as a whole, the houses were built in stages by James Emerson & Son over a period of about fifteen years between the late 1830s and the mid-1850s, as the land became available to buy. Both builders lived in the street for much of their lives, their yard being at the top of the street on land still owned by a firm of builders.

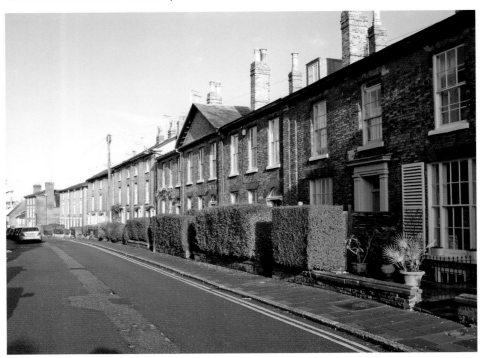

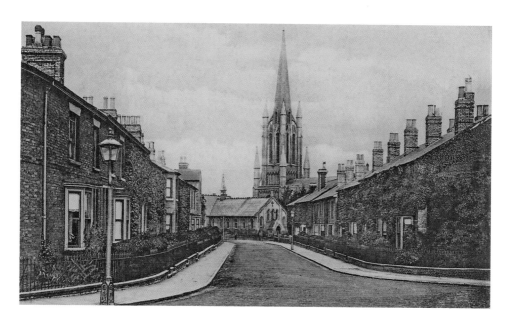

Orchard Street

Orchard Street was built on a former orchard from 1866 onwards. The Bury St Edmunds Permanent Benefit Building Society, founded in the same year, gave mortgages to clients providing their house value exceeded £110! A very desirable neighbourhood to live nowadays, the properties here have far exceeded their original value. In the distance from 1841 is St John's Church by architect William Ranger. Alongside is his St John's Infants' School, the school closing in 1972. It became the St John's Centre, catering for recreational and social needs.

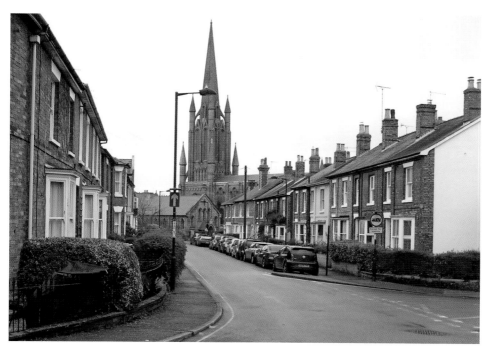

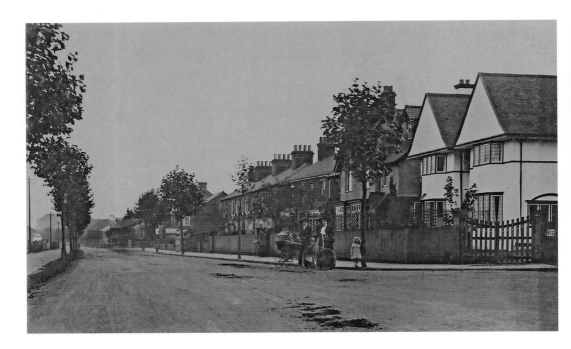

Fornham Road Looking West

This was once called Northgate Road, which led to a part of the town called the Babwell Fen. The medieval Babwell Franciscan Friary (today's Priory Hotel) is nearby. Nos 109–111 Fornham Road, on the corner with Norfolk Road, are a pair of fine semi-detached Edwardian houses from 1904. More Edwardian terrace houses are further along from these. Opposite, housing from the 1960s is set back off the road. Still evident is a pollarded plane tree on the corner that has become much grown over the years since the sepia photograph was taken.

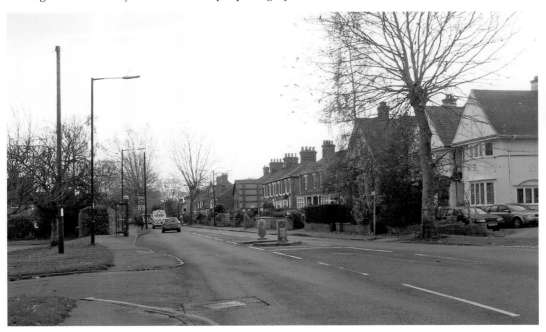

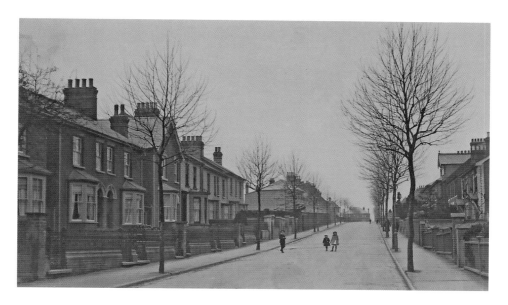

York Road Looking West

On 3 May 1887, Bury St Edmunds Town Council agreed to rename the existing Upper Brown Road to Queens Road in honour of Queen Victoria's golden jubilee. Lower Brown Road became York Road. The Brown element had come from the previous landowner, Mr George Brown of Tostock Place, Tostock. Victorian villas such as the semi-detached Sydenham Villas, on the right, built in 1891, are interspersed with later properties. A gap on the left of the sepia photograph now has modern housing, York Close. This replaced short-term prefabs built to alleviate a housing shortage soon after the Second World War.

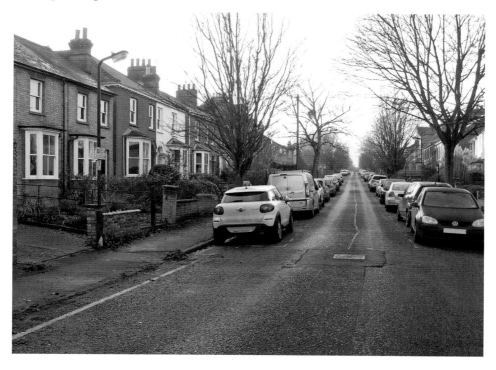

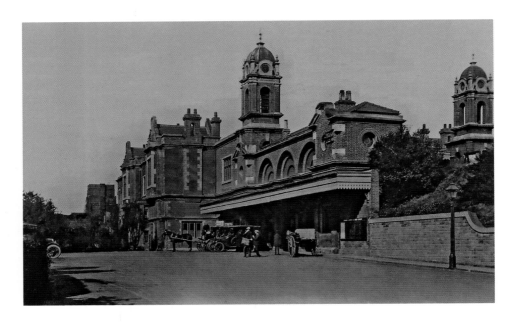

Northgate Railway Station

This railway station opened for use on Christmas Eve 1846. However, the turrets denoted it was a terminus, as the line to Cambridge was not completed. Designed by Dublin station architect Sancton Wood, it is one of the finest Victorian stations in the country. When finished, the roof projected out from the lead-capped twin towers; this roof was removed in 1893. Over the years, this Grade II listed building has seen parts of it fall into decay. Fortunately, the stationmaster's house to the left has been restored, and more awaits.

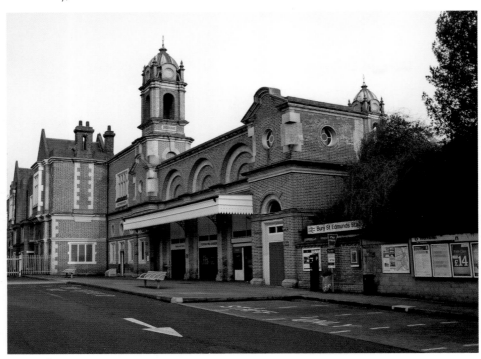

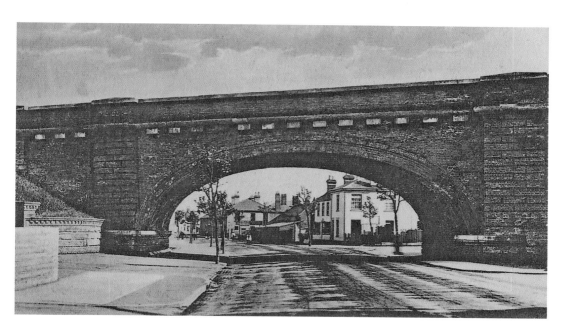

Northgate Station Bridge

This bridge was designed by Ipswich architect Frederick Barnes (1814–98), who worked on several East Anglia stations, and completed in time for the Ipswich & Bury Railway to use in 1846, with the grand opening on 7 December 1847. The bridge, now Grade II listed, is described in the listing as 'An Italianate style with a tripartite elevation in white brick and a skewed-arch brickwork'. Through the arch on the right is the Railway Hotel that also opened in 1846. Years later it had name changes, becoming The Linden Tree, then The Station and has now reverted back to the Linden Tree!

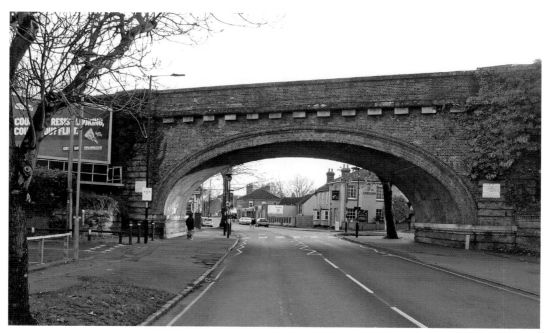

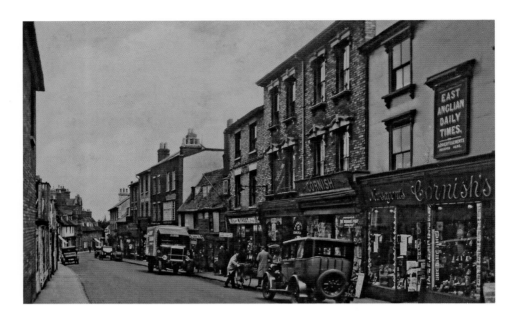

Looking Down St Johns Street

Two-way traffic is evident around 1925. Many changes of usage over the years have seen the Cornish double-fronted newspaper shop become Andy's records, which finished in 2003, Jaegar upmarket fashion store, and now the Olive Tree restaurant. The Cornish shop later became The Wolf, a Wetherspoon pub, Benson Blake Burger Bar, and then The Tavern, also now gone. Further down, Frosts Jewellers at No. 87 is now the pink-painted St Nicholas Hospice Shop and adjacent to that is Elizabeth Gash knitwear shop, with the former premises of Pledgers shoe shop becoming a Dogs Trust shop.

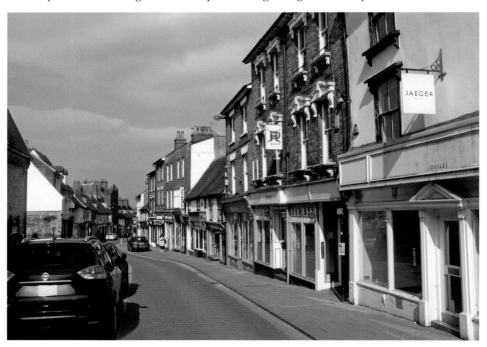

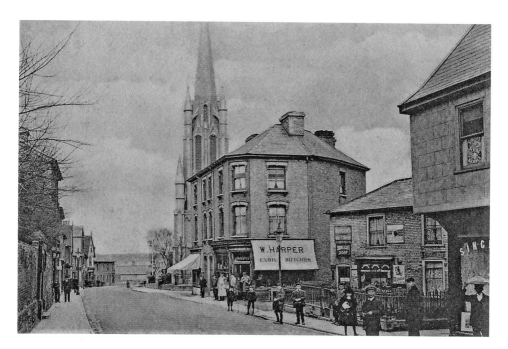

St Johns Street Looking to the Church

On land donated by the Marquess of Bristol, the church of St John the Evangelist dominates this scene. Consecrated in 1842, it is entirely constructed of brick with a 178-foot spire. On completion of the church, the street's name changed from Long Brackland to St Johns Street. On the right at No. 63 is Singer Sewing Machines, now Zap Thai restaurant, and directly in front is the solid-looking St John's Angle building of 1880 with the butchers shop of William Harper, which is currently the Vinyl Hunter record shop, with the curiously named Smoking Monkey antiques shop next door.

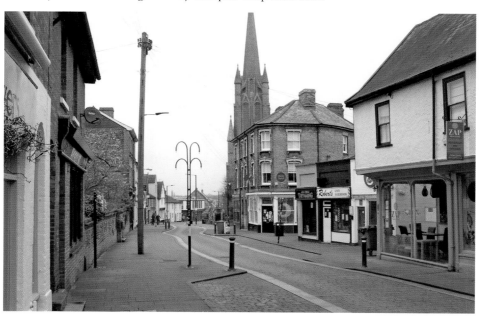

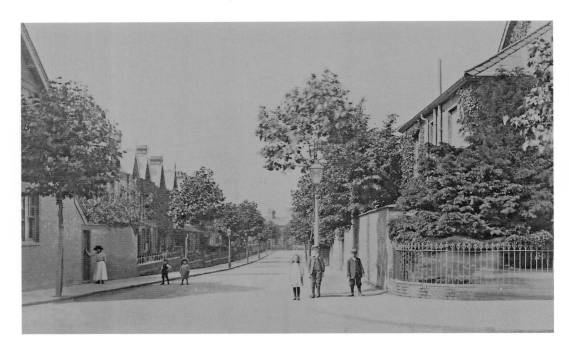

Springfield Road

Very noticeable is the lack of vehicles in this photograph of 1909, which is hardly surprising. The evenly placed trees in the sepia photograph are now infrequent due to parking needs. On the left, the fine terrace of three-storey houses with accompanying bay windows are very desirable, while opposite is a more recent development that was built in the garden and car park of No. 75 Risbygate Street on the corner. This was where Mr William Lee had his dental practice for many years, as well as Adept Dental Lab.

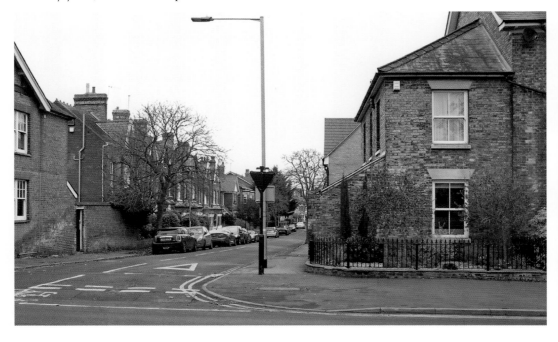

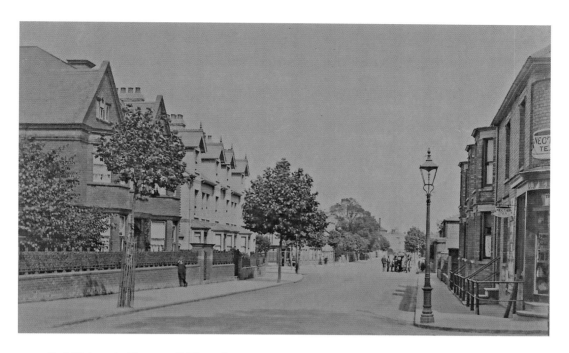

Out Risbygate/Corner of Albert Street

A view from 1921. On the corner with Albert Street is the general stores and sub-post office of Charles Fenn. Robert Skipsey was a later owner. From 1935, children attending the Silver Jubilee and the St Edmundsbury Schools, Grove Road, purchased sweets from Mrs Rachael Skipsey's shop. Much later, an amazing change of use saw Micks Mopeds trading from here, but it is now a private house. Just past the fine pair of semi-detached houses on the corner with Grove Road is St Peter's Terrace from 1902. In the distance on the corner of Spring Lane is Peter Watts Electrical, once a Co-op shop.

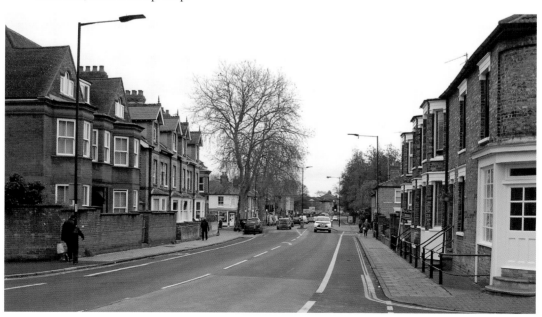

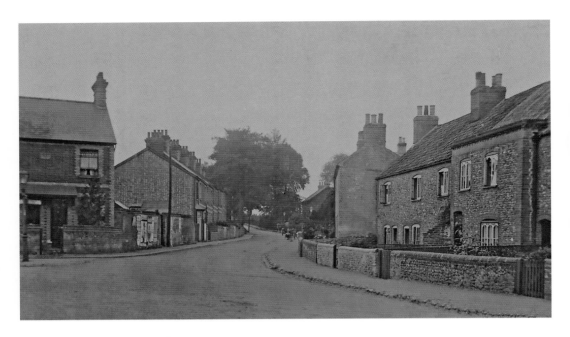

Looking Up Horringer Road

The first building that catches your eye on the left at the junction of Horsecroft Road and Horringer Road is the former Horringer Road post office. When the post office closed a large advertising hoarding was removed and a mysterious plaque with Margaret House, 1901, was revealed. I wonder who she was? Further up Horringer Road on the left are red-brick terrace houses, also from 1901 onwards. On the right is a fairly recent development of properties on a vacant site following the demolition of flood-prone nineteenth-century flint cottages. To their rear is the defunct tin hut of Mothersole's Laundry.

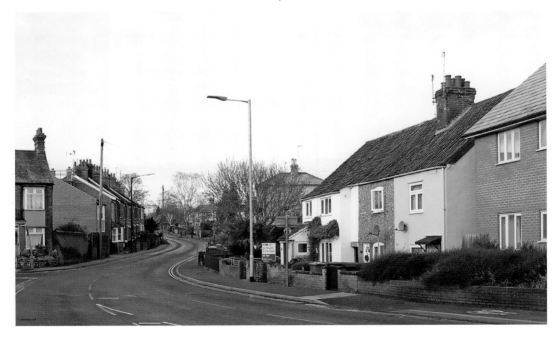

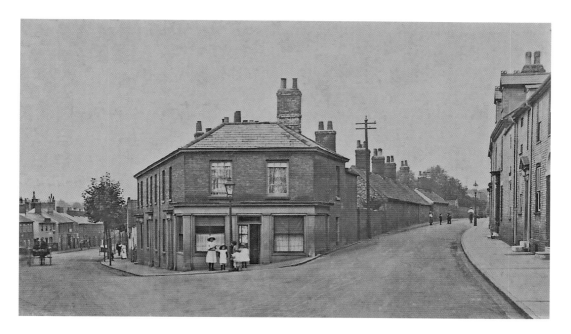

The West End

Known as Hellfire Corner, the current traffic roundabout superseded a very confusing double version. Owners of the West End 'chippy' at No. 189 Westgate Road (Out Westgate) included Harold Cracknell, who had other outlets in Long Brackland and St Andrews Street South, and John and Ellen Emblem, who kept it from 1947 to 1987. Down Out Westgate, the 1840 Baptist Church is now offices and on Hospital Road modern-day St Peter's Terrace replaced Westgate Place cottages. Nearby, the Elephant & Castle pub, aka 'The Trunk', is no more and the road now has no vehicular access off the roundabout.

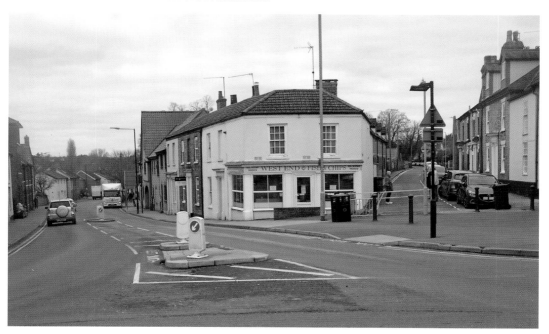

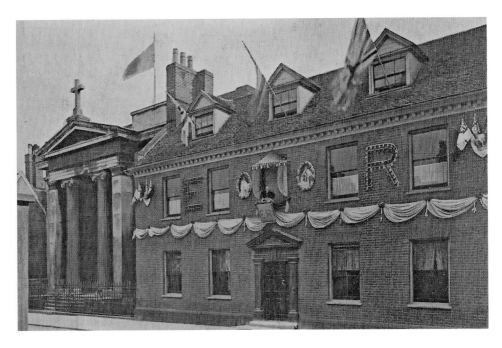

Catholic Church and Presbytery, Westgate Street

The sepia photograph shows bunting celebrating the coronation of Elizabeth II on 2 June 1953. The Roman Catholic Church of St Edmund the Martyr, built in the classical style to designs by architect Charles Day of Worcester, was dedicated on 14 December 1837. The church, in continuous use from day one (excuse the pun), has twelve rows of numbered box pews for the congregation, one of Suffolk's largest. Previously, mass was conducted in an eighteenth-century chapel at the rear of the adjoining building, the presbytery at No. 21 Westgate Street.

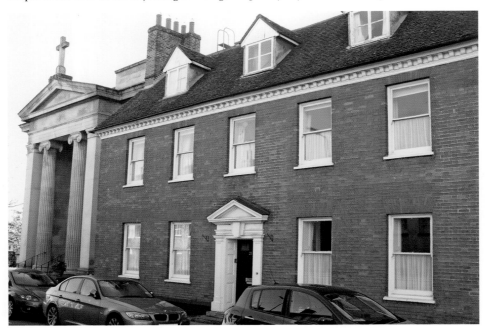

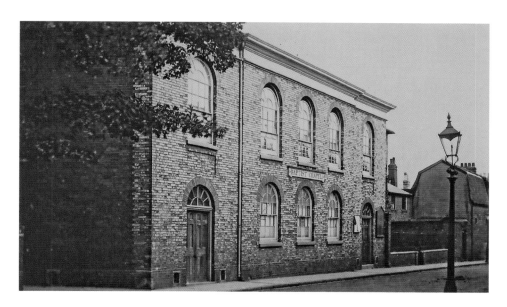

Garland Street Baptist Chapel

Although now referred to as a Baptist church, it was built in 1834 as a chapel by William Steggles for the princely sum of £1,000, beating an estimate by Joseph Trevethan. Unlike a church, a chapel is often a place of worship that has no regular pastor or priest; however, in this case a charismatic pastor, Revd Cornelius Elven, led his flock here for fifty years until ill health led to his resignation in March 1873. The congregation attendance zenith was reached in the 1860s with well over 600 members, gradually reducing as the years went by to fewer than 100 these days as the popularity of religion declined.

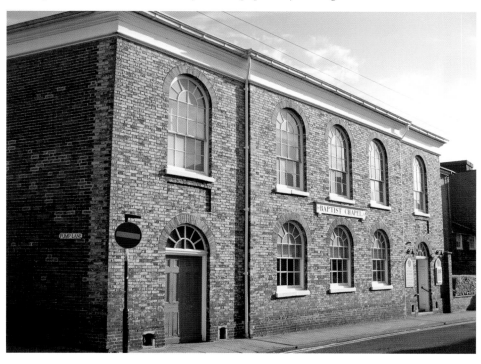

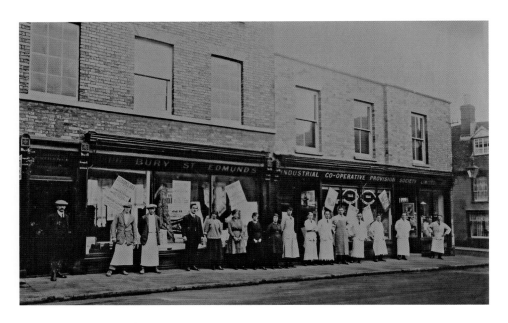

Nos 19–20 Brentgovel Street

Soon after 1885, photographs on postcards appeared. This allowed seventeen Bury St Edmunds Industrial Co-operative Provision Society Limited employees to pose for their photographs on this postcard, manager Joseph Clarke and secretary John Reach amongst them. Their prominent, partly three-storey premises on the corner with Garland Street had a bakery in the rear, which opened in 1927, eventually relocating to Western Way. The building, with its altered façade, has had several businesses since the Co-op closed, one being Bartletts Furniture, until recently becoming Revel Outdoors independent cycle shop.

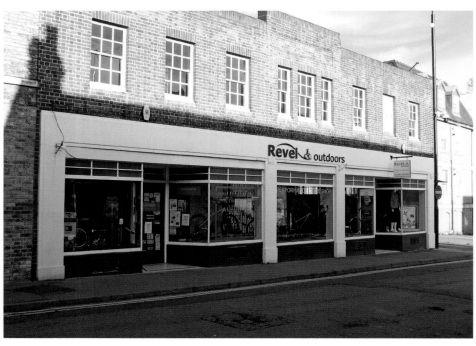

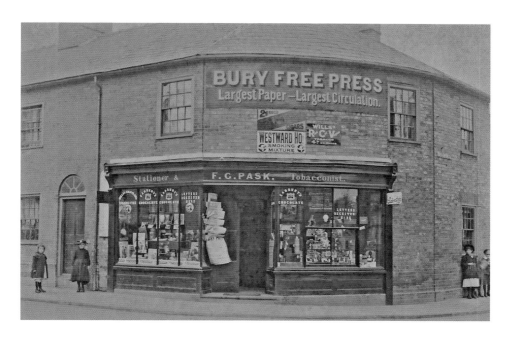

Pask's Shop, No. 65 Northgate Street

This shop, on corner of Tayfen Road with Northgate Street, was swept away with others for the creation of the Northgate Roundabout in preparation for the link to the new Bury bypass, which officially opened on 7 December 1973. Florence Pask's newsagents and tobacconists shop curiously sold, as advertised, Westward Ho! smoking mixture, available from 1882 to 1915. Also demolished were Roy's Fish & Chip Shop and Northgate Street post office. In their place Northgate Lodge sheltered accommodation was built in Long Brackland including Nos 15 and 16 Tayfen Road (shown).

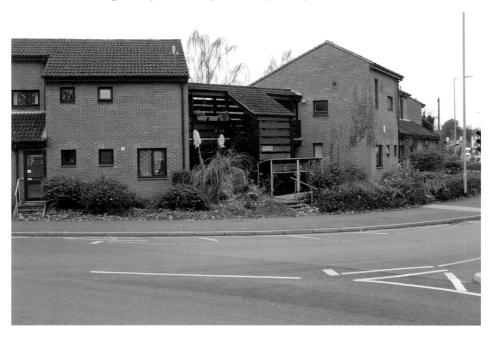

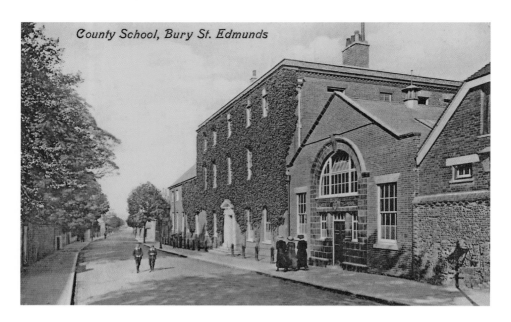

County School, Bury St. Edmunds

County School, No. 110 Northgate Street

This large red-brick building was purchased in 1904 to become the West Suffolk County School. An extension was added in 1907 (photograph from at least 1917). Edward the Confessor's coat of arms representing the county of Suffolk is on the extension. Originally a mixed school, in the early 1950s it became the County Grammar School for girls, boys still attending the Grammar School at the Vinefields. The girls' school moved to Beetons Way in 1964 to become the County Upper School, reverting back to being co-educational. The Northgate Street building, now known as Regent House, became offices.

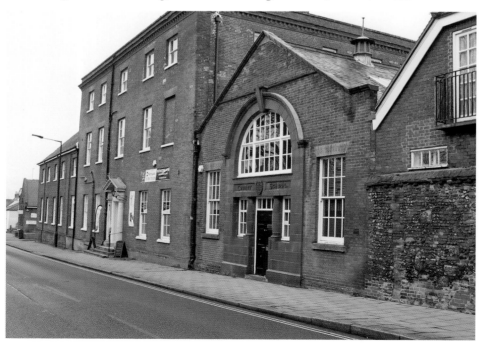

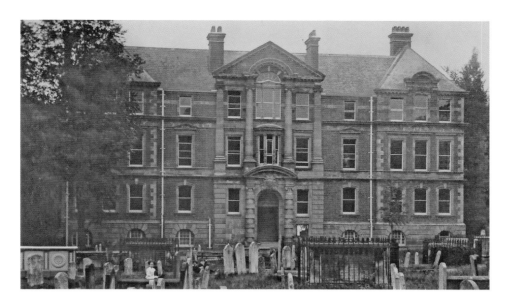

The Shire Hall

Chosen by the Guildhall Feoffees, Archie Ainsworth Hunt (later the Diocesan architect) designed the Shire Hall in 1906. Its predecessor of 1841, in classical style, was no longer fit for purpose. His edifice opened in 1907, costing £10,340, and was described as 'Edwardian neo-baroque' style. In 1974, it ceased to be a Crown Court (Assizes), though it still doled out sentences as a magistrates' court. In October 2016, the government closed the courts and sold the building off, thus ending a proud association with Magna Carta, the town's motto being 'Shrine of a King, Cradle of the Law'. Now listed, future conversion awaits!

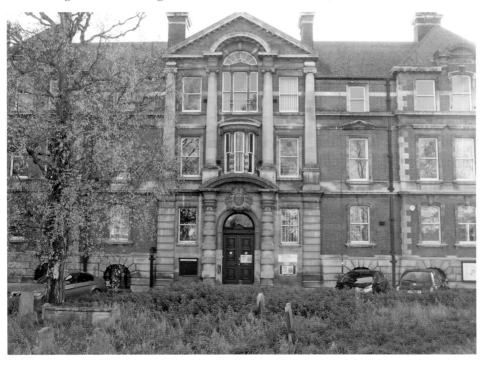

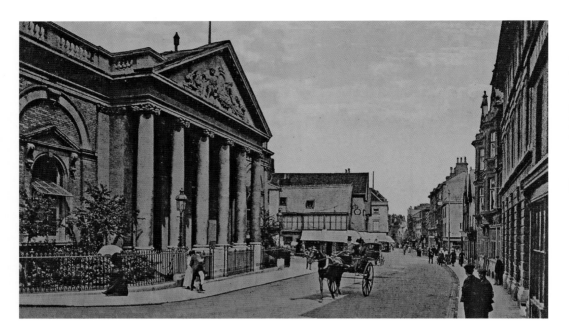

Corn Exchange, Abbeygate Street

The Corn Exchange of 1861 was in use for the trading of grain until 1997. By then, it had been split in two, with shops below and a public hall above. Acquired by national pub chain J. D. Wetherspoon, a rebranded Corn Exchange opened as a pub in 2012. The railings on the Corn Exchange have gone, as has the National Provincial Bank opposite and the Alliance Assurance Offices. These became Café Rouge, then Damson & Wilde restaurant. On the corner of Whiting Street today is Cotswolds outdoor clothiers. Previously, this shop had been chemists, Lloyds, Smalleys, and other reincarnations for 200 years.

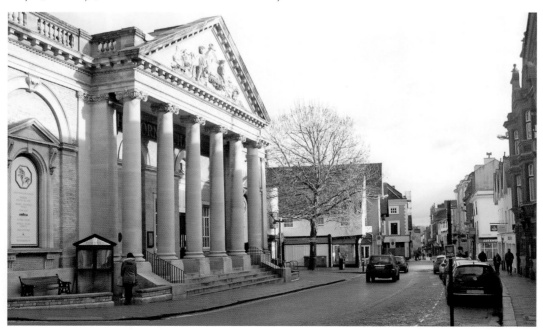

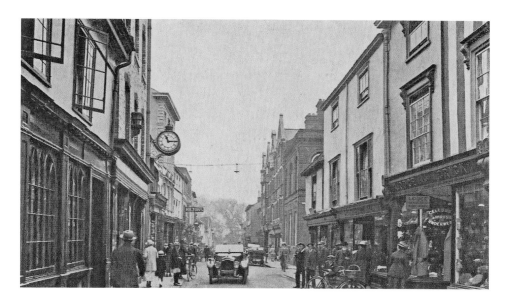

Abbeygate Street and Clock

The late eighteenth-century Gothic-style shopfront of Olivers the grocers is now a branch of Greggs bakers, praised 'as the fanciest in the UK', on the left. Opposite at Nos 47–48, various clothiers and outfitters have traded here, Walter Nunn, Aubrey Wilks, and Stanley Strickland amongst them, and it is currently White Stuff clothiers. The prominent clock was made by Leeds firm Potts & Co. in 1900 for Thurlow Champness jewellers, who after 277 years made way for Dipples Jewellers. Two-way traffic is evident in the sepia photograph – not so now. The one-way street at times is pedestrianised, save for the electric litter collection wagon!

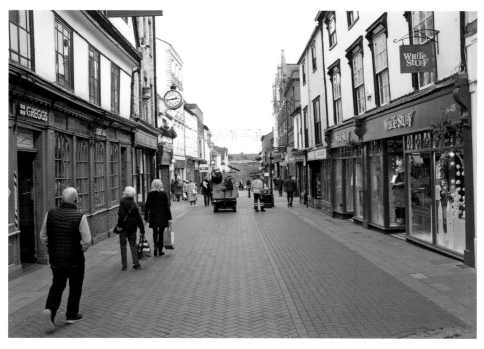

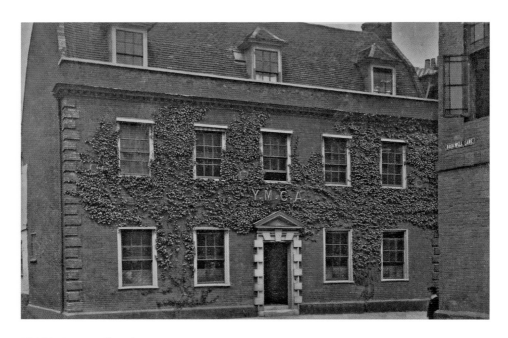

YMCA, No. 35 Churchgate Street

No, not the song by the Village People. The YMCA letters stand for Young Man's Christian Association, formed to give shelter to young people in London in 1844 and in Bury St Edmunds in 1905. This was thanks to a generous donation by Great Barton Hall owner Frank Riley-Smith, master of the Suffolk Hunt. The mid-eighteenth-century Grade II listed property is now called Churchgate House. Its owner from 2009 has been former Secretary of State for Employment Baron Norman Tebbit of Chingford. An acerbic wit, he is renowned for a speech at the Conservative Conference of 1981, 'to get on your bike' to find work.

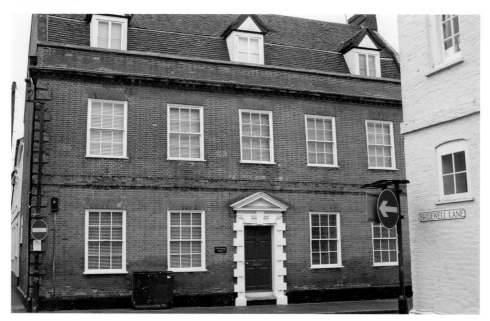

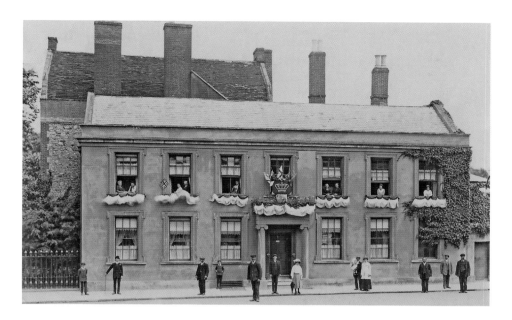

Abbey House, Angel Hill

The Davers family, prominent landowners of Rushbrook, purchased the abbey site and Abbey House, which became their town house. They would marry into the Hervey family of Ickworth. On the death of the matriarchal Mary Davers in 1805, Abbey House passed to Lord Bristol. He sold it in 1831 to become a boarding school run by Miss Ann Fulcher some years later. The garlands are out to celebrate the coronation of King George V on 22 June 1911. In recent times, the cathedral and David Burr estate agents moved into offices here, whilst opticians Peel & Gudgin have been here since the 1970s.

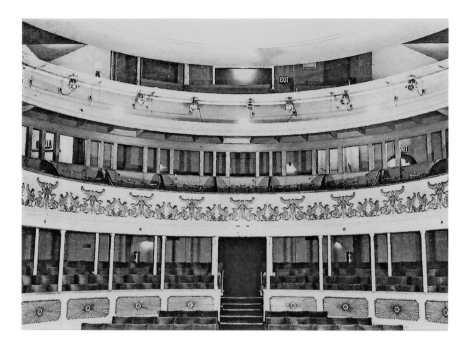

Theatre Royal

This Grade I listed Regency theatre opened in 1819. Its most famous production was *Charley's Aunt*, a risqué play that had its premiere in 1892. However, the theatre later closed, languishing as a barrel store for owners Greene King from 1926. The great and the good of Bury fundraised for the theatre's restoration in the 1960s, reopening in 1965. The National Trust obtained a lease in 1975 from Greene King. Bucket seats from the closed Playhouse cinema of 1959 were utilised. Seating became a bone of contention after the fine restoration of 2005–2007; the auditorium now has bench seating.

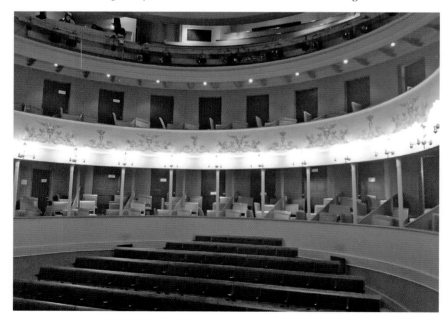

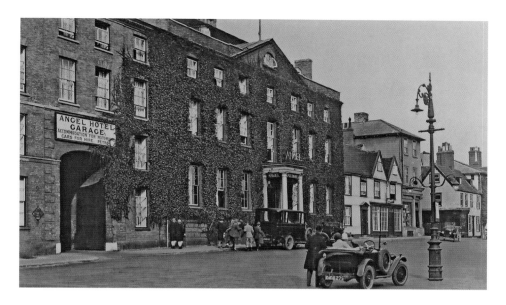

Angel Hotel and Garage

Dickens has his eponymous hero Samuel Pickwick staying here when the Angel was an important coaching inn. The stabling was in Angel Lane at the rear. In 1818, an extension by William Steggles was built to the left of the tall archway entrance where coaches once went through. The twentieth century saw this extension become St Edmund's Hotel, now part of the Angel Hotel. The arrival of the railway saw horse-drawn carriages travel with potential tourists from the railway station to the Angel. The hotel had its own garage at one time.

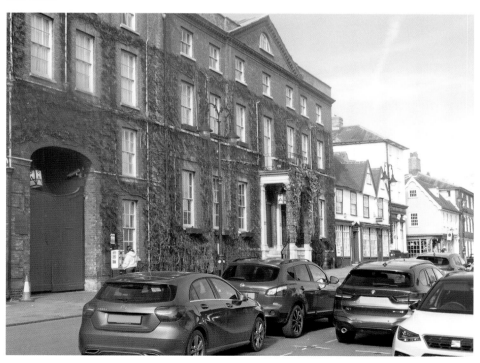

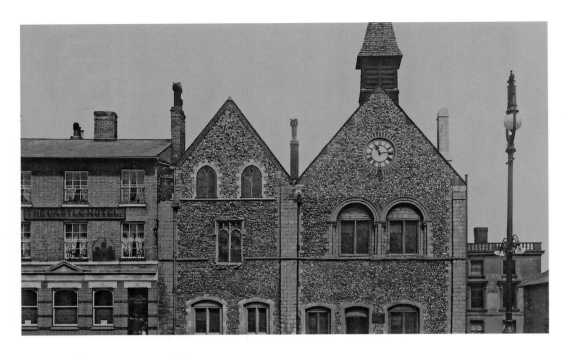

Moyses Hall Museum, Cornhill

The museum was once thought to have been a synagogue as its name was similar to Moses. Now disproved, it was a merchant's house from the late twelfth century. It has a colourful past: a house of correction, gaol, left parcels office, etc. It became the Borough Museum in 1899. It has many fine historical collections inside, and the knowledgeable staff put on many exhibitions – the sci-fi exhibitions proving very popular. To the left in the sepia photograph is the Castle Hotel, once a carriers inn with a flying freehold cellar to Moyses Hall. The Castle closed in the 1980s. In the distance on the right is part of the White Lion pub, replaced by the ill-fated Cornhill Walk shopping mall.

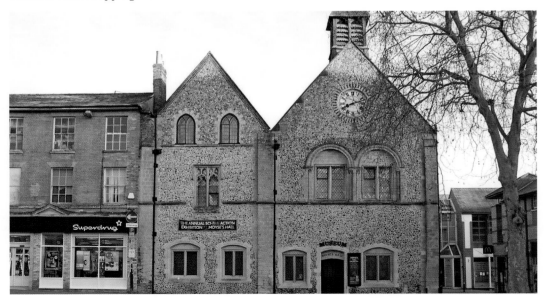

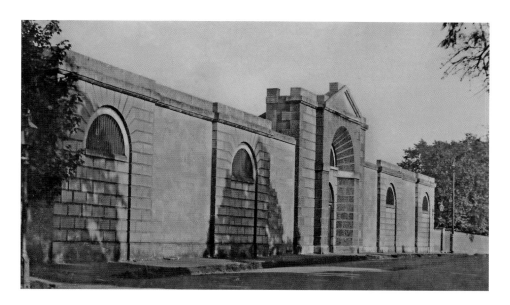

Bury Gaol, Sicklesmere Road

The façade is the most prominent remaining part of the former Bury Gaol, which had a central raised gatehouse constructed of stone blocks with vermiculated rustication (worm casts), built in 1805. George Byfield was the gaol's architect and its enlightened governor was John Orridge. The most infamous criminal hanged here was William Corder in 1828, while the last was George Carnt in 1851. The gaol closed in 1880. During the latter part of the twentieth century, properties were built against the gaol façade forming part of new homes. During construction, the gaol's infilled cellars and cells caused problems for the builders.

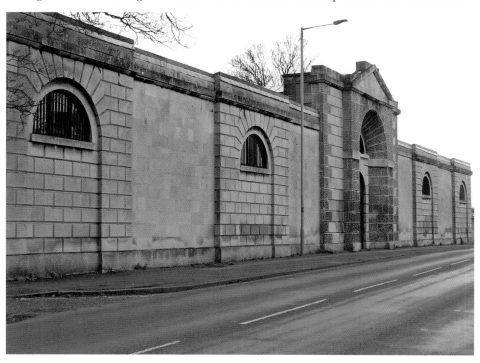

Angel Hill and One Bull

The foreground scene has changed very little other than Burrell's garage and its fuel pump are no longer there, Cycle King Shop replacing it, which was rebuilt after a disastrous fire in 2017. The sixteenth-century One Bull, its emphasis on fine dining, now has had its archway to the courtyard covered in, its hanging sign metamorphosing over the years. Further along are Warrells Grocery Stores and Snell & Co., who manufactured mineral water. A restaurant echoing the street number, 1921 Angel Hill, was at one time Bells House Furnishers, whose proprietor was Stanley Bell. When Bells ceased, Tomorrow's Kitchens was here for a while.

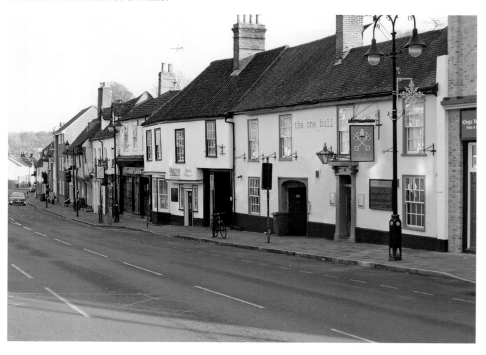

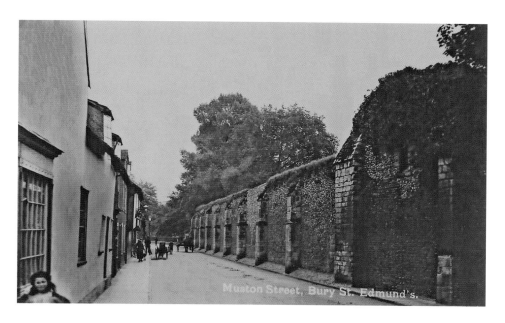

Muston Street, Bury St. Edmund's.

Mustow Street to Fox Inn

Spot the spelling mistake – this is not Muston Street! Widening took place in 1926 from the corner of Cotton Lane to the Fox Inn. Ancient timber-framed cottages opposite the north curtain wall of the abbey (there is a small ceramic doll hidden in here) were demolished, though some were reused in the rebuild of No. 17. Prior to the widening, the ancient Star Inn, a carrier's inn, closed in 1923, it too suffering demolition. A strange anomaly is that traffic would flow easier with the widening, but somebody then decided to put in parking lay-bys, reducing the width to where the street was originally.

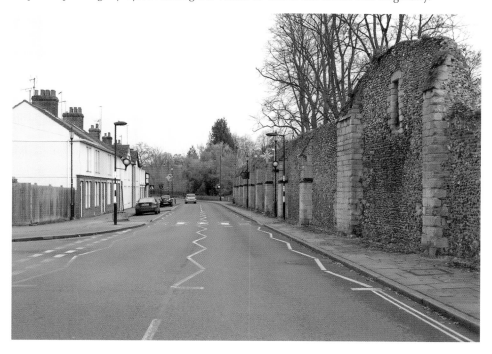

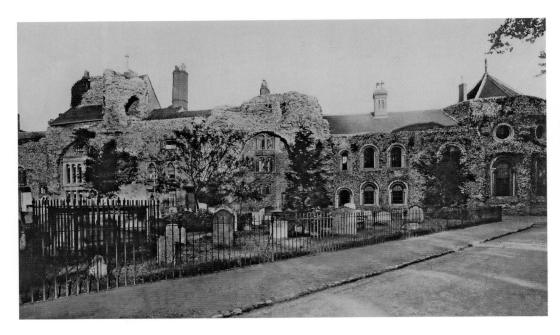

West Front of the Abbey

At 246 feet across the west front of the abbey church is one of the widest in the country, with octagonal chapels and a tower the height of which we can only speculate. This must have presented a magnificent entrance to the abbey church. Through the central arch in 1533 travelled the funeral cortege of Henry VIII's younger sister, Mary Tudor, Queen of France. The west front is unique amongst monasterial buildings as it incorporates houses built into it during the late seventeenth century. In 2006, during restoration of these, a track from hobnails of monk's sandals was discovered in the upper parts of the west front. Note that there are no longer headstones!

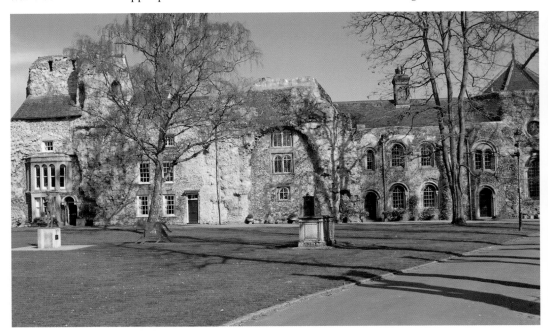

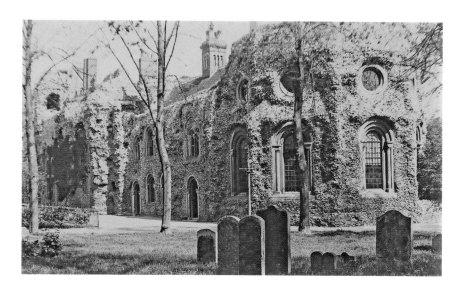

Samson's Tower

The abbey church's west front has this octagonal chapel as part of Abbot Anselm's magnificent build, named after another great builder of the abbey, Abbot Samson. Once in use as a probate or will office, the tower mirrored its companion, now removed, on the north side. In Richard Yate's *History of Bury*, published in the early nineteenth century, it is shown with a thatched roof. During the latter part of the twentieth century, it became a visitors' centre until being occupied by renowned artist Lillias August, whose watercolours of the cathedral's Millennium Tower under construction (2000–05) are absolutely superb.

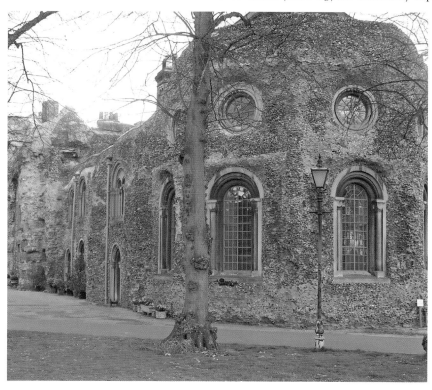

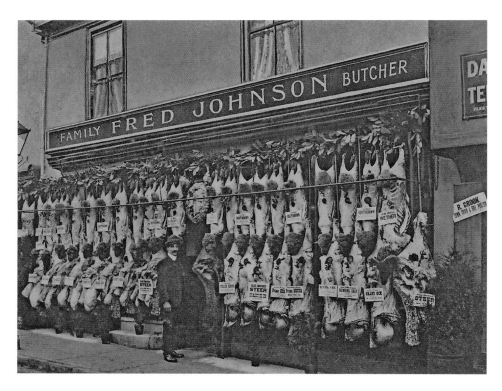

Nos 6–7 St Johns Street

Just before 1904, Fred Johnson purchased this existing butchers shop from Charles Sneezum, whose family owned two other butchers shops in town. The 1914 photograph shows Fred's quality meat on offer. Later, a new owner, Mr W. J. Cotton, traded as F. Johnson until Robert Hopwood took over in 1953, trading under his own name until 1977. Recent years have seen businesses come and go, including Casa Del Mar restaurant and Wolf in Sheep's Clothing, which opened in 2017. Founded by Paul Brown in 2009, his company manufactured designer tailored shirts at his Brandon factory. Alas, the shop did not last.

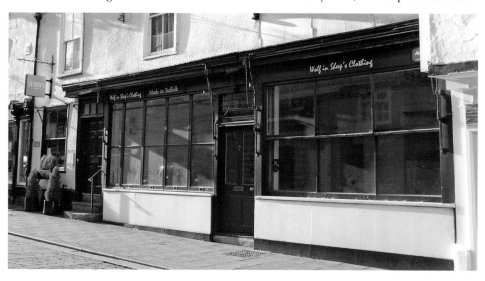

No. 3 Whiting Street

Baker Henry Charles Coley has his shop bedecked with flags for the 1907 Bury pageant. In 1910, he introduced a new system of keeping delivery records for his bread: the customer would be issued with an invoice book to fill in each week, which was then returned to him to avoid any errors. The shop was eventually demolished during the 1960s. Whipps & Co. Ltd fishmongers went into the new premises. Former Ipswich Town footballer Mick McNeil then had a sports shop, later to become Intersport. In 2020, Moriarty's Espresso opened, closely followed by Baskervilles in 2021, a vegan coffee and innovative cocktail bar.

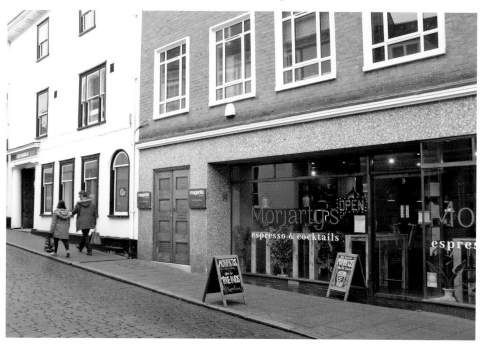

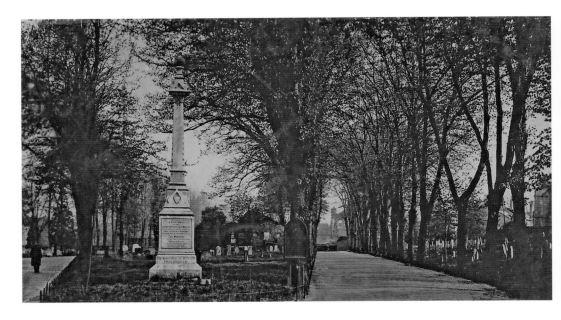

The Martyrs Memorial

A public subscription enabled this prominent Purbeck limestone obelisk to be erected in 1903 by Hanchets, a local firm of stonemasons. The names of seventeen Protestant martyrs are inscribed on the panels, although strangely none from Bury St Edmunds, but places such as Coddenham, Hadleigh, and Stoke by Nayland. These ordinary people, labourers, weavers, etc., died for their faith during the short reign of Queen Mary (1553–58). Her sobriquet 'Bloody Mary' was earnt because she tried to bring back the Catholic faith through burning so-called heretics. Note: some of the gravestones are now removed.

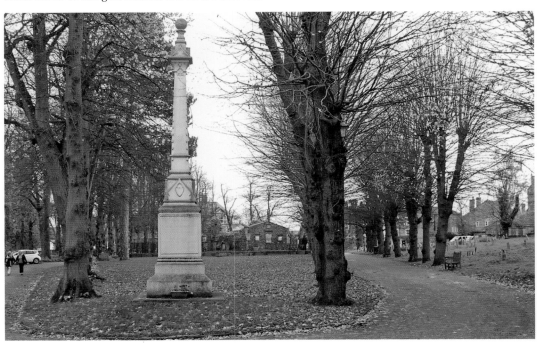

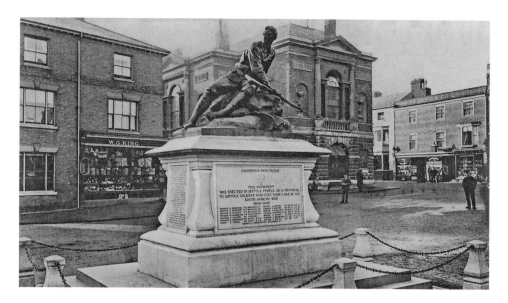

South African War Memorial

This war, often referred to as the Boer War, has this splendid memorial to it by Arthur George Walker, unveiled by Lord Methuen on the auspicious date of 11 November 1904. Assisting in the ceremony were Archdeacon Hodges and the Marquess of Bristol. A volley of rifle fire to the 193 men from the Suffolk Regiment listed on the memorial echoed around Cornhill. A rededication took place in May 2002 after those men's names who had made that supreme sacrifice thousands of miles away were recut. Unfortunately, over the years the bronze figure has 'bled', causing an unsightly green stain.

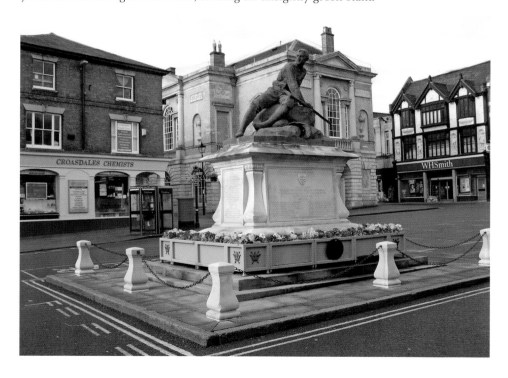

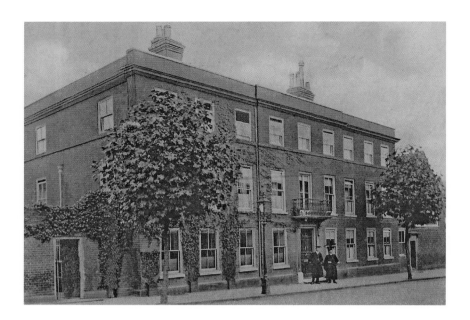

Mustow House

The stamp on this postcard states 22 November 1908 and the information reads 'Dear Agnes, I thought you would like a photograph of our school'. This postcard has a strange anomaly. In print at the end it reads 'Northgate School, principal Mr Norman Martyn'. However, it is listed in Kelly's Directory of 1908 as Mustow House, Day and Boarding Boys School, with Mr Martyn as the principal! After the Second World War, it was the headquarters of Bury Red Cross for a while. Still known as Mustow House and now split into three residential units, it has an incredible twenty-six windows facing the street. Strangely, one window facing west is no longer there.

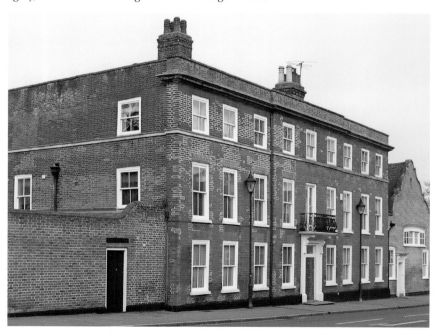

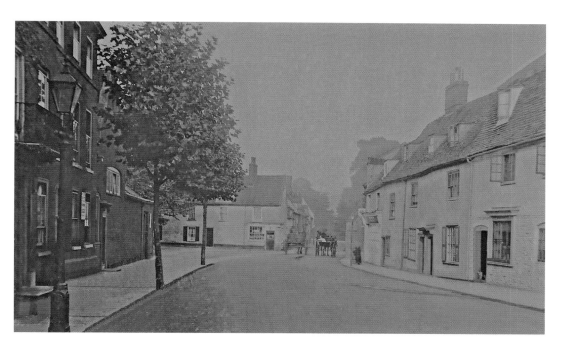

Mustow Street

Mustow from Le Mustowe, to muster, to meet. On the left is Mustow House, opposite eighteenth-century Grade II listed cottages that were restored by the Bury St Edmunds Town Trust in 1981. The builders were Nayland Building Services. Further on the left is Hawkes Garage from 1928, probably the oldest in the town, then the entrance to Cotton Lane, aka Scurff Lane in medieval times. The large corner house was demolished in the road widening of 1926. Opposite is the Abbey Gardens side entrance and F. Clutterham & Son Funeral Directors. They started as motor body builders but are now part of Dignity Funerals.

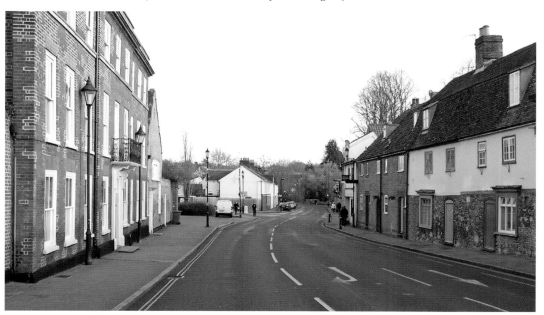

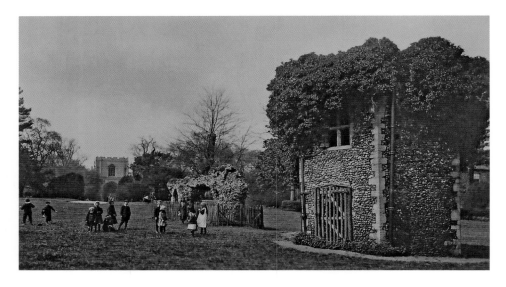

Looking Past Abbey Dovecote

The sepia photograph has the Abbeygate clearly visible, something the modern-day photograph does not allow. Overgrown with ivy, thankfully now removed, a dovecote, known by the French name of Colombier in medieval times, was an important source of food for the monks. Still evident are the nesting holes. Being so close to the River Lark, this area was always prone to flooding, as happened in 1879 when a grand gala with all sorts of attractions was wiped out following torrential rain. Currently, the well-liked Abbey-Fest takes place near this spot with various live music entertainment. It is still a popular play area for children.

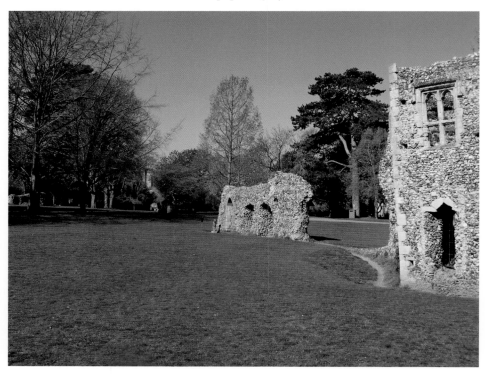

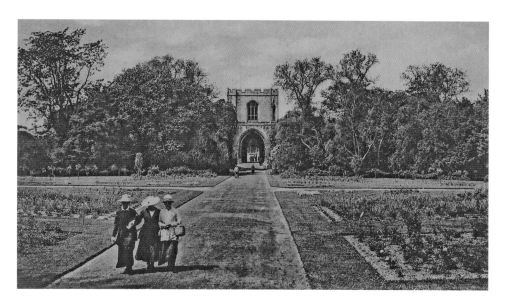

Abbey Gardens Looking West

On the site of the Great Court of the abbey, these gardens were established in 1831 by its creator and curator Nathaniel Hodson, utilising designs from the Royal Botanical Gardens in Brussels. A wonderful amenity for the many thousands of visitors and residents of the town, these gardens contribute to Bury winning numerous floral awards over the years. Lovingly attended by its gardeners, their work contracts prohibit digging down further than 1 foot without dispensation as any archaeology beneath may be compromised.

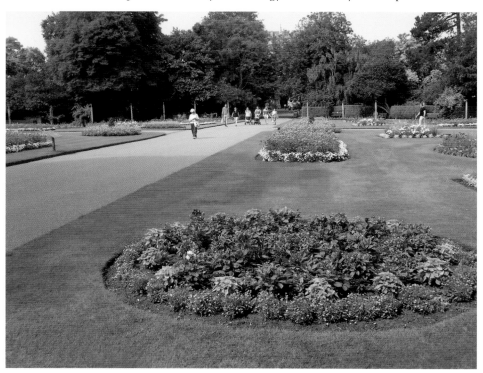

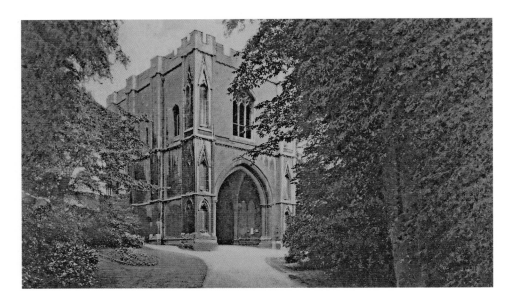

Inside the Abbeygate

After the townspeople destroyed its predecessor twenty years earlier, this 60-foot-high secular gateway to the abbey was built in 1347. The rear has a fine east-facing tracery window and niches for statues – now gone, as have those at the front. A lovely feature missed by the hundreds of thousands of visitors that come through this gate annually is on the string course. If they looked above their heads, they would see various stone carved animals including cats and pigs. An impressive gateway, it is locked at dusk.

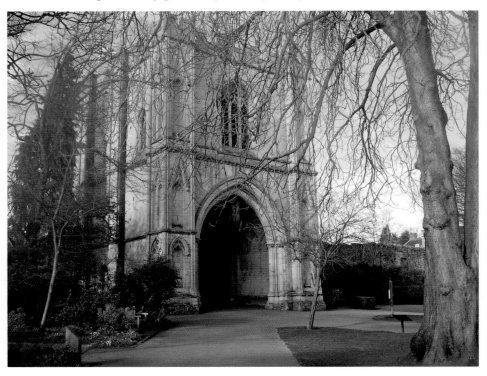

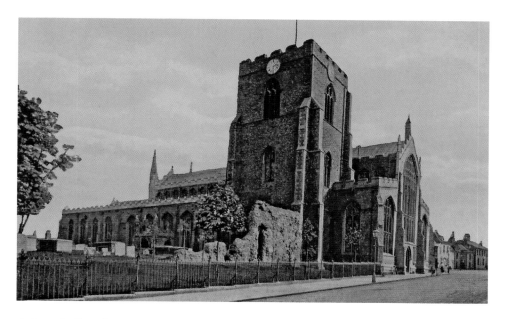

St Mary's Church

This fifteenth-century civic church of the town is a fabulous repository of history. With the last resting place of a queen of France, Mary Tudor, a west window that is the largest of any parish church in the country and a fabulous carved Angel Roof over an incredibly long nave, it has an air of tranquillity inside. Each June, it holds the oldest endowed service in the country from 1481 to benefactor Jankyn Smyth, which is still celebrated. The tower of *c.* 1400 has a clock from 1897, installed to celebrate Queen Victoria's Diamond Jubilee. Strong winds cracked the clock's south face in 2020.

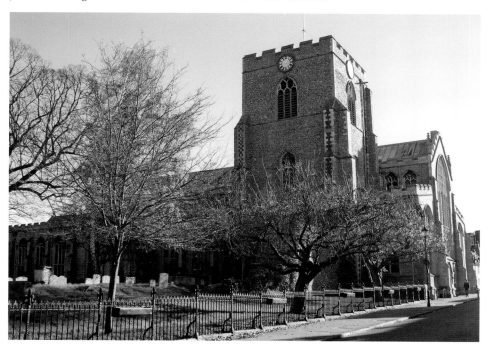

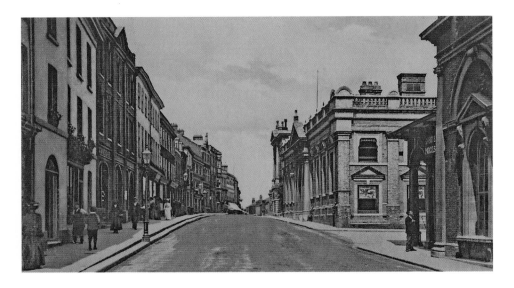

Looking to Cornhill, 1907

This shows the incredible difference of the buildings and their successors on the western side of Cornhill. The premises of William Cook, picture framer, Alfred Ives, pianoforte retailer, and Ransomes, Sims & Jeffries, agricultural manufacturers, are all gone. The latter's site would eventually see Sainsbury's, St Edmunds Fayre, and finally Iceland. Opposite, just showing is the Great Eastern Railway Parcel Receiving Office and the Shambles. Further along is the Corn Exchange of 1836. Deemed too small, it would later become the School of Art, a fire station, and the Borough Library but now is tearooms and a bank.

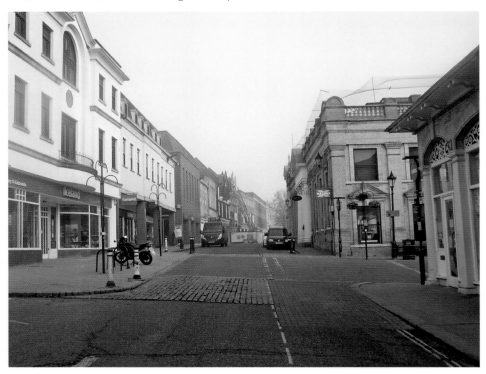

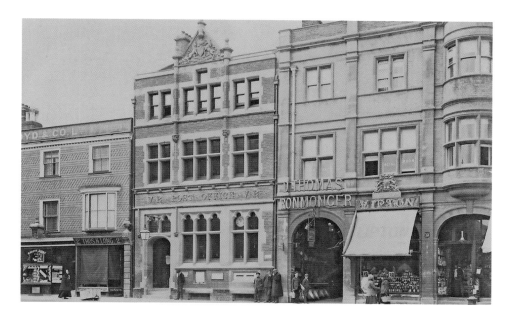

Post Office

Boots with its wonderful façade was built on the site of Floyd & Co. Chemists in 1910. Adjacent, the post office of 1895 replaced The Bell Hotel, beside which was Bell Arcade/ Market Thoroughfare. Following the purchase of the redundant post office by the then St Edmundsbury Borough Council, innovative development plans plus improving the link to the arc were announced. The façade's right-hand window was made into an arch, followed by an arcade. David Thomas' ironmongers and Liptons grocers became Andre Bernard hairdressers and Stead & Simpson respectively, their overhang removed in 2009.

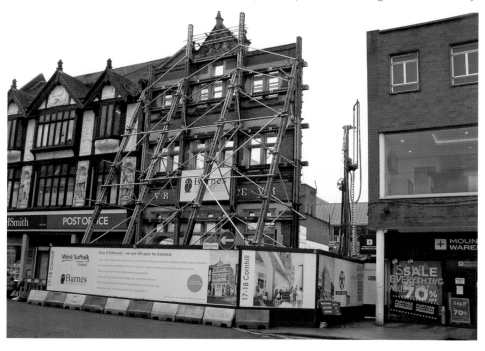

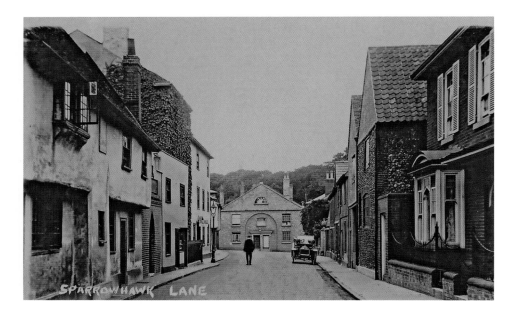

Sparhawk Street

I decided to keep the postcard title as it shows how postcard publishers, in this case Farringdons, can get it wrong – it is not Sparrowhawk Lane. Opposite the ivy-covered Missionary Children's Home on the left (it would later move to Norman House, Guildhall Street) are some flint-built properties that would be demolished to make way for flats. The biggest change to this scene though is in the distance: the Millennium Tower of the cathedral. This magnificent addition to the town's landscape was completed in 2005, five years after its construction started in 2000. The contractors were Bluestone.

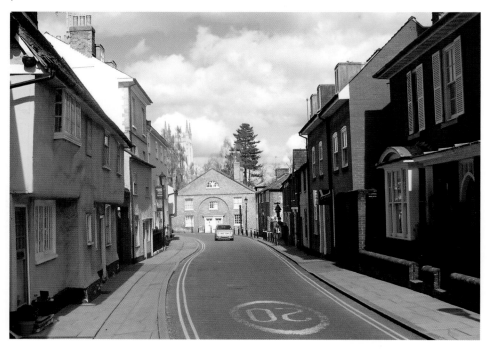

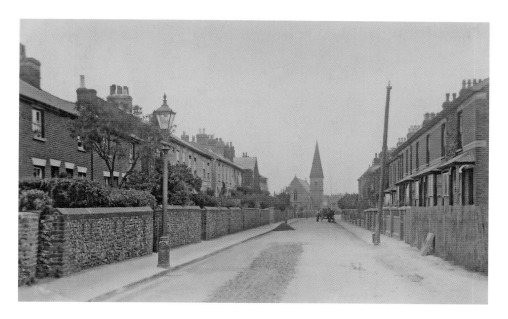

Hospital Road

Originally called Chevington Road, the Suffolk Hospital being built here in 1826 led to the name change. Later named the West Suffolk Hospital, it moved to Hardwick in 1973. Still very evident is the spire of St Peter's Church, built in 1858 as a chapel of ease for St Mary's. Now a cul-de-sac, the image of 1915 shows it as a through road with popular terrace housing. Union Terrace on the far left, where Louise de la Ramee, prolific Victorian author, was born, now gives way to St Peter's Court, a housing development that replaced the hospital.

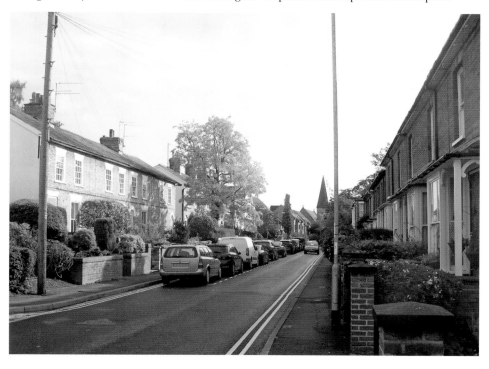

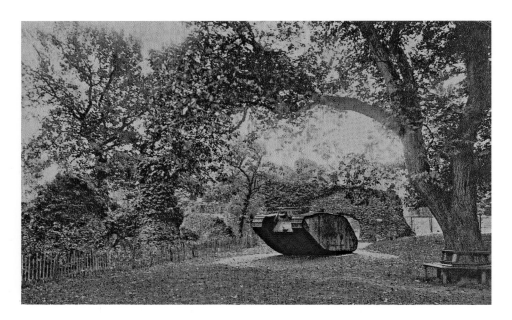

Tank in Abbey Gardens

In December 1919, Bury St Edmunds was presented with a defunct Mark I British tank sporting the name *Kaffir* with the number 8093. Given to the town in recognition of the noble efforts by the local war savings committee in raising money for the war effort, this tank amazingly had seen action on the Somme in 1916. A concrete pad (still there) was provided for the tank in the Abbey Gardens where it stood until 1933, when it was removed after some people deemed it too 'militaristic'. Avis & Co. Ltd Electricians & Engineering in College Lane later dismantled it for work benches.

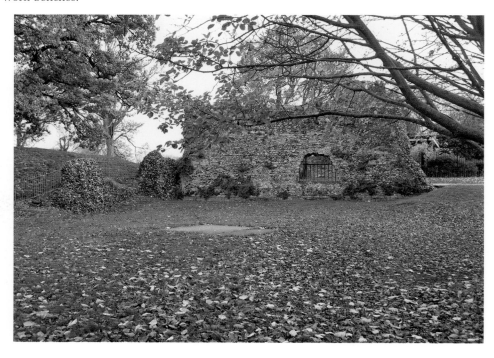

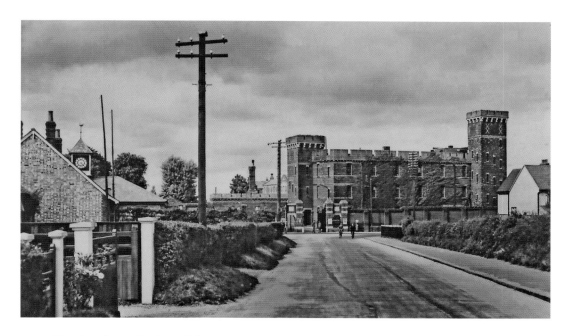

Gibraltar Barracks, Out Risbygate

One of only a surviving handful, these barracks were named after the 12th Regiment of Foot's heroic defence of The Rock for nearly four years from 1779. The 'Old Dozen's' (Suffolk Regiment, now part of Royal Anglian Regiment) greatest battle honour was victory over the French at the Battle of Minden, 1 August 1759, which is still celebrated today. The barracks had accommodation blocks including married quarters, a gym, hospital, messes, and importantly a parade ground! Sadly only some curtain walls and the keep housing the Regimental Museum remain as much of the site is now given over to West Suffolk College.

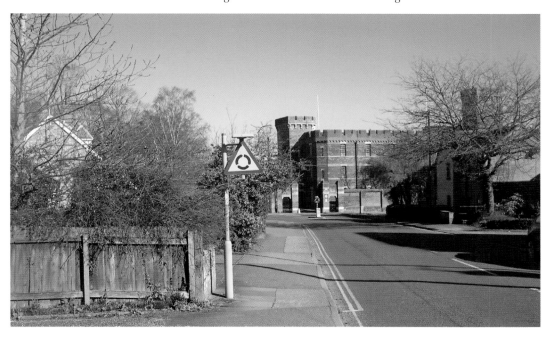

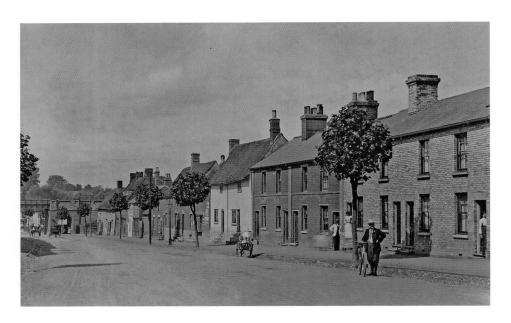

Looking Down Eastgate Street
In the far distance is the Sudbury to Bury rail bridge. The nearby Eastgate station closed in 1909 and was demolished in 1924, but the line operated until 1961. The A14 Bury bypass that opened in 1971 followed the same alignment of the bridge. On the left, the short-term prefabs of East Close were built just after the Second World War to alleviate a housing shortage. The pink property on the right, once the Unicorn pub, would have an adjacent development, Unicorn Place. Who can forget the fully loaded sugar beet traffic endlessly trundling up this street during the campaign, their route replaced by Compiegne Way.

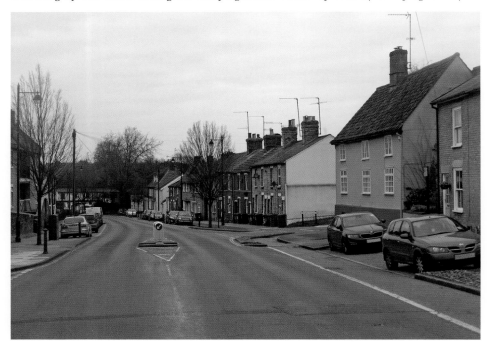

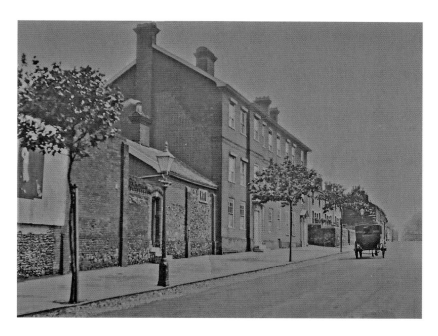

Nos 42–43 Southgate Street

At the rear of South Hill House, No. 43, on the corner of St Botolphs Lane, a small chapel was owned at one time by the Catholic recusant Father John Gage, who held prohibited Catholic church services here at the end of the eighteenth century. Later on, a Protestant, Madam White, became a subsequent tenant of the house and for a while lent her name to St Botolphs Lane – Madam Whites Lane. There's an apocryphal story that No. 43 was the Westgate School featured in Dickens' famous novel *The Pickwick Papers*, but no actual proof exists.

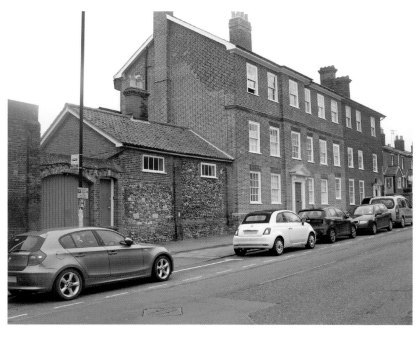

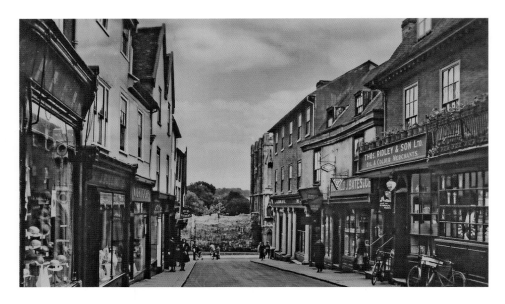

Nos 35–36 Abbeygate Street and Ridleys

Pre-1935, as there is no Pillar of Salt traffic signage! Ridleys, founded in the mid-nineteenth century, were superlative grocers with quality service. They also traded as decorating merchants here until moving across the road to take over John Bullings drapers and clothing shop. In business from 1886 to 1961, currently it is Phase 8 ladies' fashions. Ridleys sadly closed in 1996 because of high business rates. It subsequently became different restaurants – Chez Gerard, Café Uno and presently Prezzos. Adjacent were Ronald Bates & Co. electrical engineers at No. 34 Abbeygate Street, currently Neal's Yard skincare and herbal remedies.

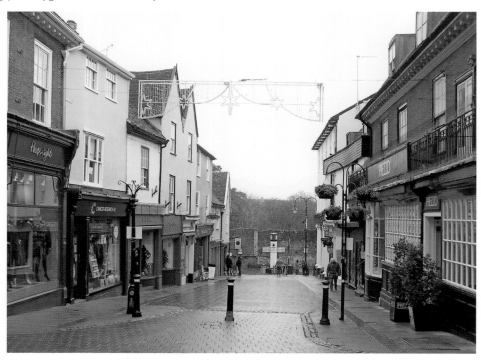

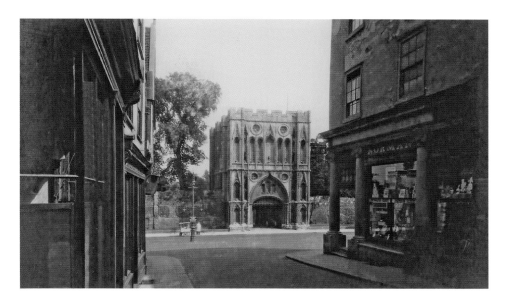

The Abbeygate from Abbeygate Street

1327 saw rioters push cartloads of burning straw down this street, then known as The Cook Row, destroying the Abbeygate. Abbot Richard de Draughton rebuilt it by 1347. He obviously did not want a repeat performance, hence why it is not opposite the street. Missing from the sepia photograph is traffic signage called the Pillar of Salt, designed by architect Basil Oliver in 1935; not conforming to normal regulations, it was Grade II listed in 1998. On the right-hand corner is Arthur Norman's pharmaceutical chemist. Burdon & Leeson later had a chemists here, now the Really Rather Good Coffee and Tea House.

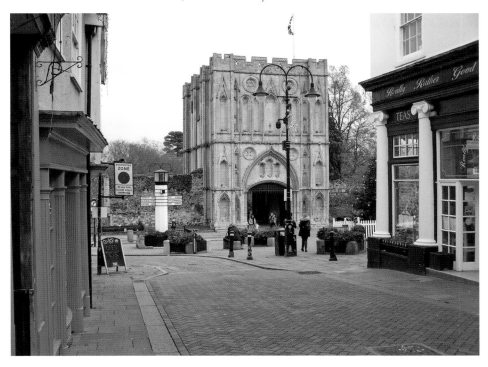

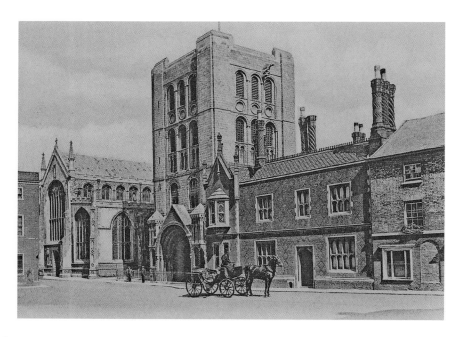

Chequer Square

A theory that this is where the abbey kept its exchequer or treasury has been debunked; the abbot would hardly have allowed the abbey's wealth outside of its protective walls. In medieval times water collected here from down Churchgate Street, the square known as Paddock Pool. At the northern side of the square, on the corner with Angel Hill, stood the ancient Six Bells coaching inn, the St Edmunds Masonic Lodge taking the building over in 1890, before becoming apartments after 2014. Norman Tower House of 1846 with its oriel window, adjacent to the Norman Tower, was once the Savings Bank.

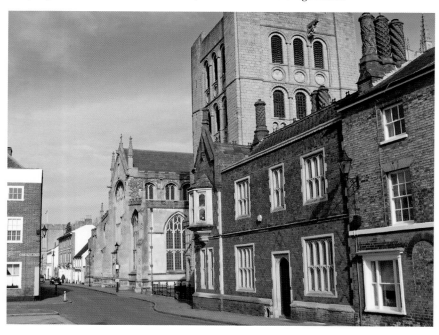

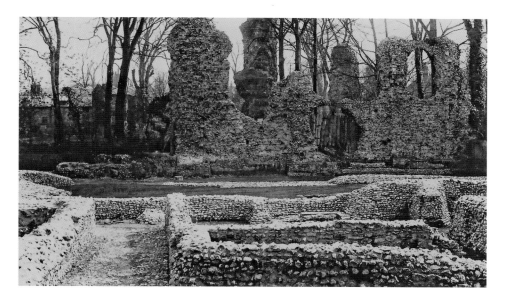

Cockerel and Kettle

The Benedictine St Edmundsbury Abbey was one of the largest and richest in the country, with the shrine of St Edmund a big attraction. The abbey owned, taxed, and controlled the town of Bury St Edmunds. So at the dissolution and at the behest of Henry VIII, the abbey was taken down by the townspeople ensuring it would not come back to haunt them. All that remains today is the flint and mortar core, stripped of the limestone ashlar casing. To the keen eye looking southwards two shapes appear: on the left a 'cockerel' complete with an eye and on the right a 'kettle'!

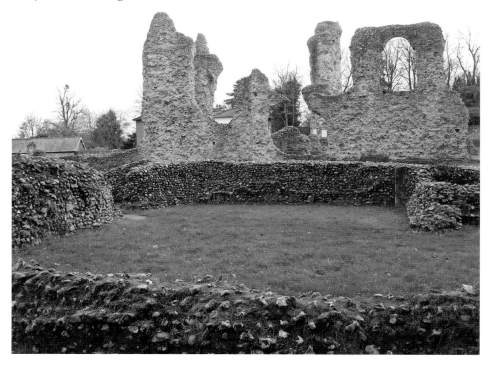

Abbots Graves

Famous ghost writer and academic M. R. James discovered the whereabouts of six abbots of St Edmundsbury Abbey whilst researching in Douai, France. They were in the Chapter House and on New Year's Day 1903, they were disinterred. Five were in coffins, one was not. Most famous was that of Abbot Samson, who was buried with the silver tip of a crozier, a religious staff. Local stonemasons Hanchets cut inscriptions on new coffin lids, for the sum of £8 12 shillings. The bill was generously paid for by Mr Donne, whose garden contained the Chapter House! As far as is known, their remains are still there.

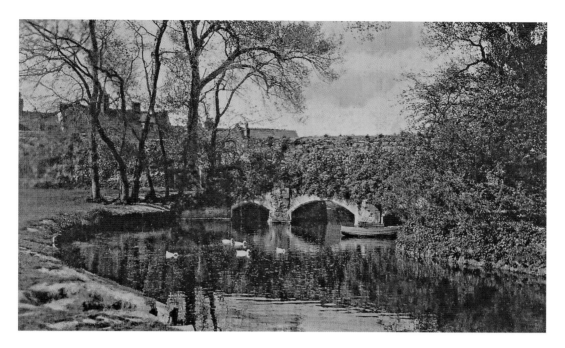

Abbots Bridge, Abbey Gardens Side

Unbelievably, the River Linnet once joined the River Lark near this bridge as it was diverted to create a mill pond for the abbot's watermill. Two fourteenth-century triangular 'breakwaters' on the bridge, which shows the flow of the River Lark, are still important when the river is in flood, though in 1921 the Lark dried up here. In the sepia photograph a boat is moored, a thing of the past. In both photographs waterfowl is evident, but feeding of the ducks is now discouraged as they leave an unsightly mess. Importantly, the riverbank is now fenced off.

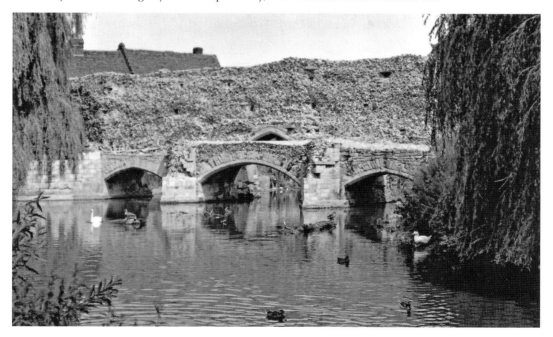

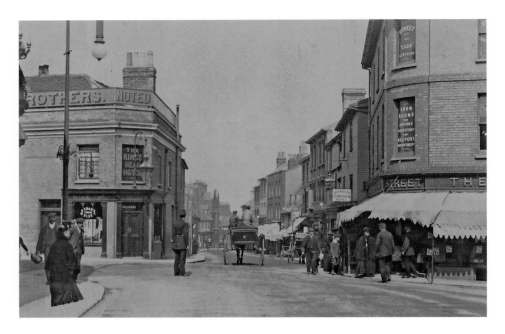

No. 93 St Johns Street, on the Corner with Brentgovel Street

This view, taken in 1906, has the tailor shop on the right-hand corner of Samuel Street, mayor of Bury in 1925. His shop became another tailors, Foster Bros, and later Greenwoods. It is now Cook, a frozen food chain offering a range of convenience foods. In the sepia photograph, opposite is former carriers inn The Kings Head. The landlord then was Walter Theobald. Closing in 1976 and demolished for a Mothercare store, note the wonderful weathervane of a stork carrying a baby! Mothercare closed in 2014, becoming a branch of Hughes Electrical.

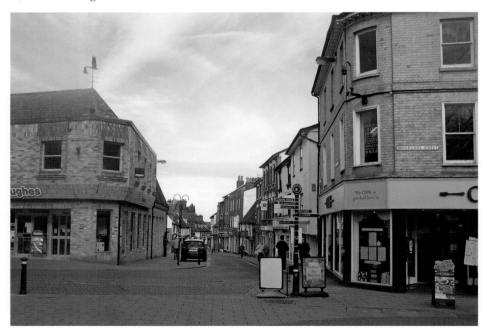

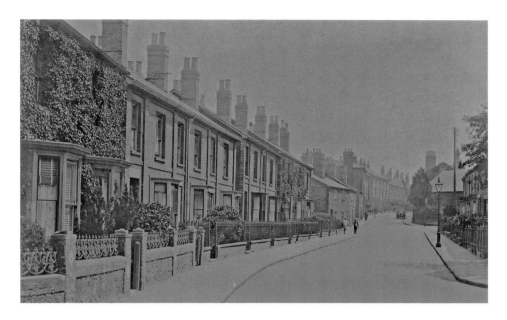

Orchard Street Looking to Well Street

This postcard of 1926 shows a street scene that has changed dramatically. A solitary car has been replaced by a whole plethora of vehicles; roadside permit parking has taken over. The garden railings are still an important element of the street and are now over 150 years old. In the distance is Well Street, which links up nicely to Orchard Street, and on the corner (red van) is the former Guildhall Feoffment Elementary Girls School of 1852. This later merged with the other two Feoffment schools in Bridewell Lane and College Street in 1936.

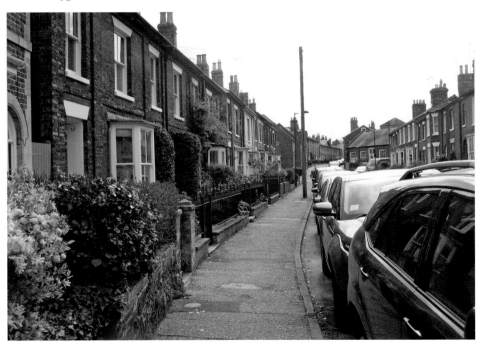

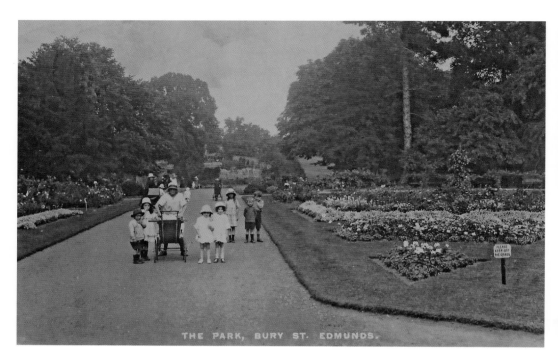

THE PARK, BURY ST. EDMUNDS.

Abbey Gardens, 1920

Following George V's coronation on 22 June 1911, the Bury St Edmunds Borough Corporation obtained a lease on the Abbey Gardens from the 4th Marquis of Bristol for £90 a year. Despite a torrential downpour a grand opening by Lady Evelyn Guinness took place on 28 December 1912, the great and the good of Bury attending. Now called the Abbey Gardens, most of 'old school' Bury can remember going to 'The Park'. The council would not own the freehold until 1953, when they purchased it to celebrate Queen Elizabeth's coronation, a fitting tribute.

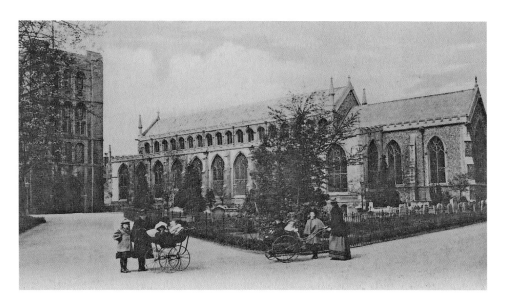

St Edmund's Green

No longer covered with headstones, as part of the Great Churchyard, they were removed in 1957–58. This particular verdant area alongside St James' Cathedral is between the abbey's west front and the Norman Tower. In recent years, the green has acquired this name from the magnificent Elizabeth Frink statue of St Edmund, erected in 1976 to acknowledge the amalgamation of West Suffolk and East Suffolk, becoming the county of Suffolk, in 1974. Since then, the cathedral has seen many changes including a new crossing and extensions, but most notably the wonderful Millennium Tower.

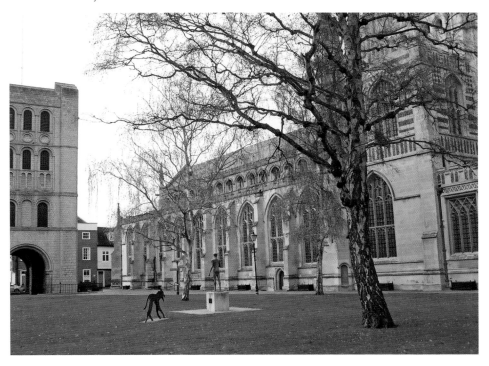

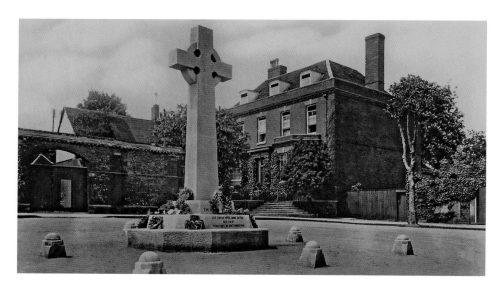

War Memorial, Angel Hill

This war memorial, in the shape of a Celtic cross of Clipsham stone, was dedicated on 13 October 1921 to the 427 fallen in the Great War, as the First World War was known then. Their names are recorded in a book of remembrance in the cathedral, the pages of which are turned daily. In the distance, a pre-Borough Offices wall can be seen. The house it belonged to was destroyed by fire in 1929. Still constant is Angel Corner, which once housed the Frederic Gershom Parkington clock collection left in memory of John Parkington, killed in the Second World War. The clocks were subsequently moved to the Manor House Museum after burglaries but are now in Moyses Hall Museum.

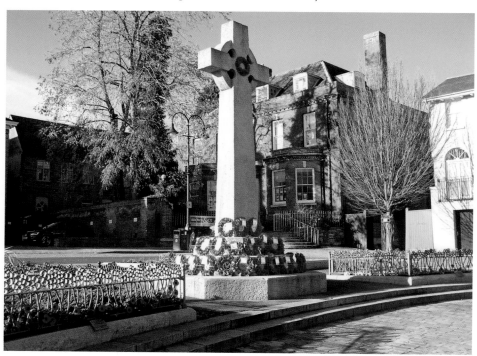

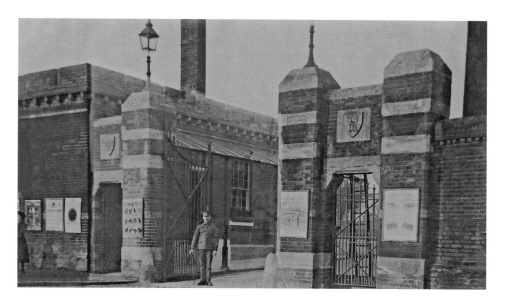

Gibraltar Barracks Gateway

Built in 1878 to designs by Major Seddon, Royal Engineers, this date is on the shield left of the gateway to the barracks. These became the depot for the two battalions of the 12th (East Suffolk) Regiment of Foot. Following the Cardwell Reforms, 1868–74, and its restructuring of the British Army, the regiment became the Suffolk Regiment. The Childers Reforms of 1881 encouraged localisation of British military forces, hence the Suffolk's home here. The barracks went on to become the regional centre for infantry training as the East Anglian Brigade Depot in 1960 until closing in 1964–65.

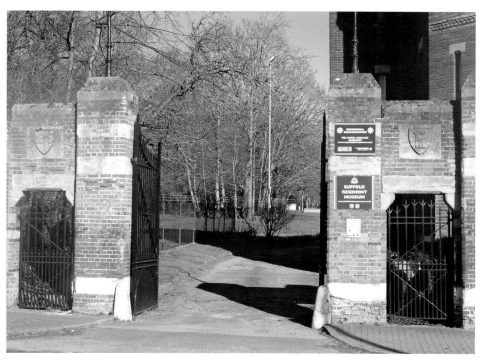

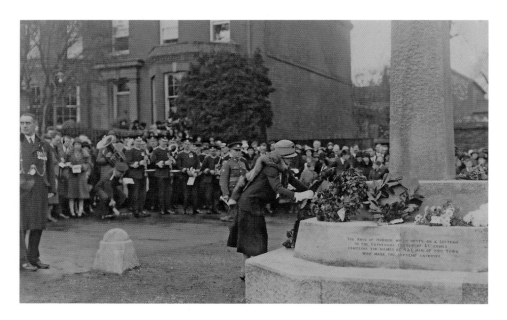

Remembrance Sunday

This is held on the Sunday closest to 11 November, the day the Armistice was signed in 1918. This sepia photograph was taken some time after 1921, the year the Celtic cross memorial was unveiled, and wreaths were laid. Seen here is a band in attendance, a member dropping his instrument! Due to COVID-19 pandemic restrictions, masks and all, the memorial service to all conflicts held on 8 November 2020 was somewhat subdued – no bands or marching. Cllr Margaret Marks, the last mayor of St Edmundsbury Council and Vice-Chair of West Suffolk Council, is seen here laying a wreath.

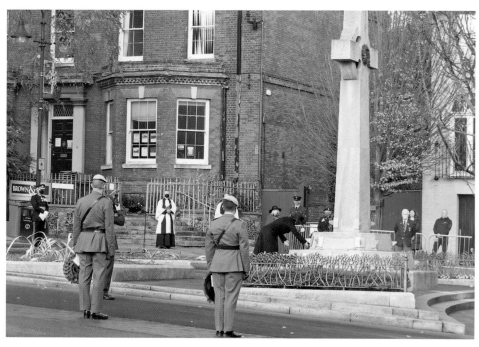

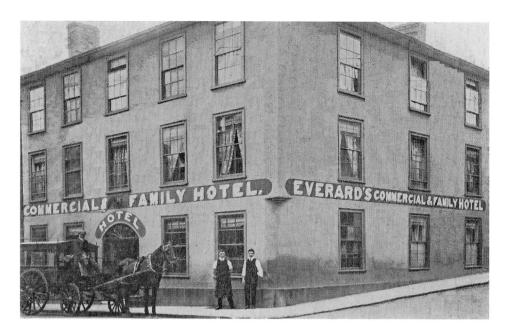

Everard's Hotel, Cornhill

The Woolpack Inn became Everard's Hotel in 1864 when Michael Everard purchased it; his family had connections to The Suffolk Hotel. As a commercial hotel with a large function room on the first floor, it was a favourite watering hole of the town. Everard's sadly closed in 1987, and many architectural features were lost when the interior was gutted, but the façade was retained. The building then became a Pizza Hut franchise, eventually closing in 2020. Soon after former market stall trader Adam Wright opened his successful eponymous Wrights Café here after being in St Johns Street for a while.

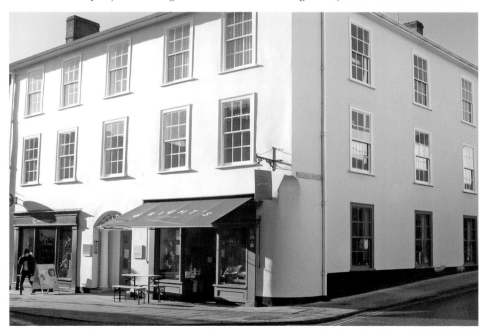

Northgate Street Looking North

The advantage of an autumnal photograph is that there is no obscuring foliage, as this photograph of 1910 shows. Once linked by a conservatory on the left, Nos 14–15 are late Victorian. No. 14 was until recently The Northgate, a boutique hotel. Opposite is the pedimented porch of the Grade II* listed No. 112 Northgate Street, which has been a dental practice for many years. Also Grade II* listed is the adjacent No. 111 Manson House. A Mrs Blanche Manson lived here pre-Second World War, the house eventually becoming a residential care home run by the Royal Agricultural Benevolent Institution, but now Stow Healthcare Group.

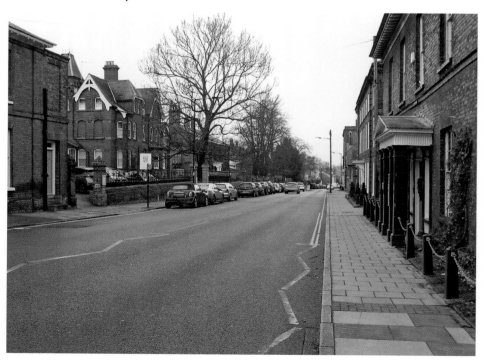

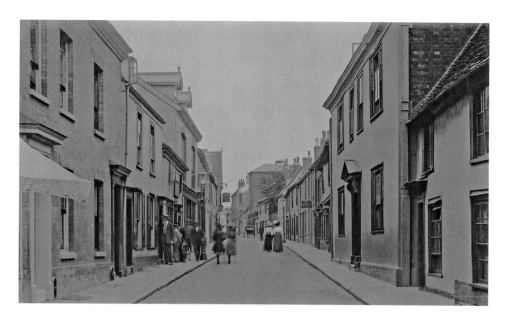

Guildhall Street

As its name implies, a major thoroughfare of the town's medieval grid has the town's Guildhall at its northern end, serving the people of Bury St Edmunds from the twelfth century as a meeting hall, court, and council chamber. During the Second World War, the Royal Observer Corps had an ops room there as well. One of many Grade II listed, timber-framed, rendered houses in the street, No. 47 Warwick House, on the right, no longer has the Mill Bakery attached to it as seen in the sepia photograph. A tranquil garden is there now, on the corner with Westgate Street.

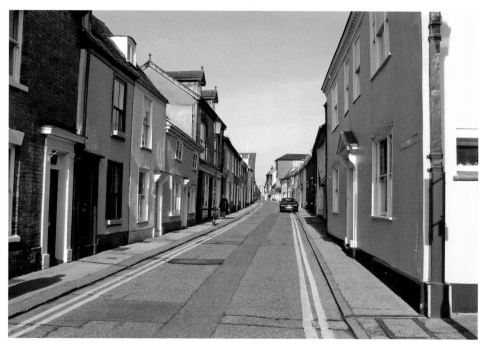

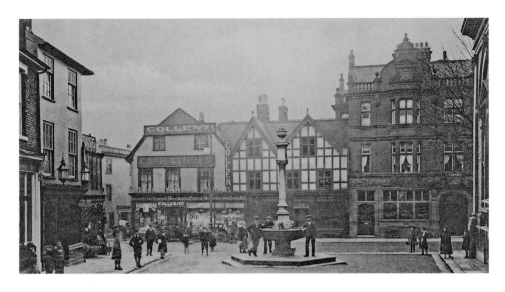

The Traverse

In this scene from 1909, the most prominent feature is the Marquess of Ickworth's drinking fountain, which was donated in 1870. Removed in 1939 to allow traffic flow, it is now in the Abbey Gardens, a plane tree in its place. Opposite, the diminutive Nutshell pub of 1873 is still acclaimed as England's smallest pub. 102 people and a dog once crammed in. Far ahead are the Alliance Assurance Company offices at No. 59 Abbeygate Street, which became Café Rouge restaurant until it went into administration in 2020. Colleens Grocers building at No. 57 is now Santander bank and Scotts Opticians moved to No. 58 from the Traverse.

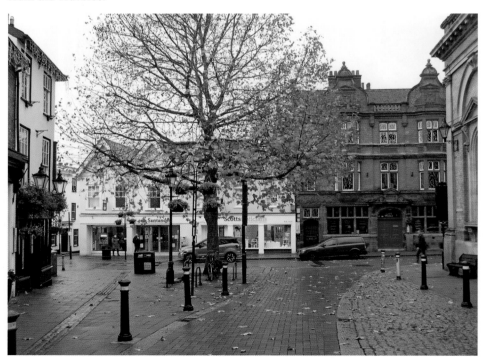

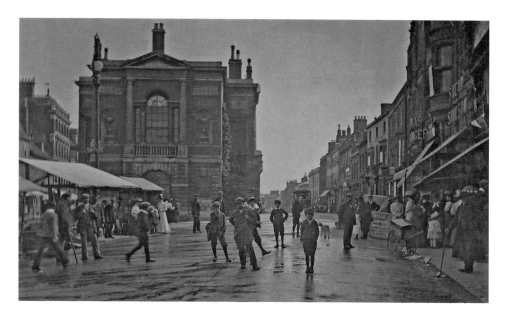

Looking to the Market Cross

The prominent Market Cross was the town hall for a period from 1840. Sadly, its ground floor is currently a bookmakers. Just visible on the right is David Thomas' Ironmongers Shop and Stead & Simpson shoe shop at No. 20 Cornhill. Today's photograph shows scaffolding and bracing shoring up the post office façade, while the rear of the post office is being converted to commercial use, with flats above. Above Stead & Simpson was Andre Bernard hairdressing salon, which has now successfully transformed into Barclays Bank. Tommy Bond's 'Licence to Grill' burger van is nearby – not quite 007, but a clever name!

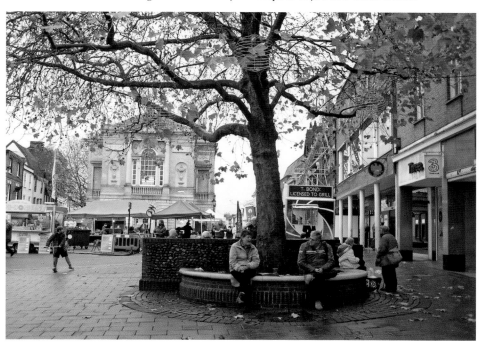

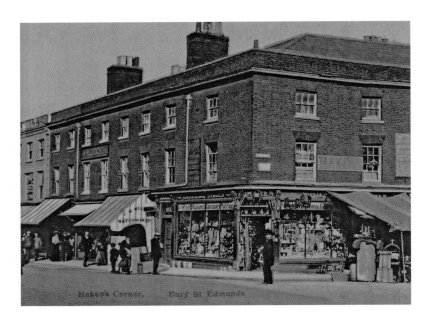

Hakens Corner

This postcard of 1916 has on it Hakens Corner at No. 35 Cornhill. R. F. Haken had branches in Staffordshire, Birmingham, and London selling all kinds of merchandise, such as china, earthenware, glass, hardware, furniture, etc. Their warehouse was at No. 5 St Andrews Street North. No. 35 would later become an outlet of the International Tea Stores. Since its closure, Thorntons Chocolate and Coffee Café traded here, now Caffe Nero. The adjacent shop at No. 34 was the watchmakers of C. W. Wilson, later to become another jewellers shop, Croydons. It is now a branch of H. Samuel.

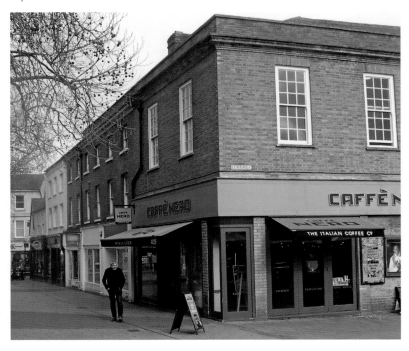

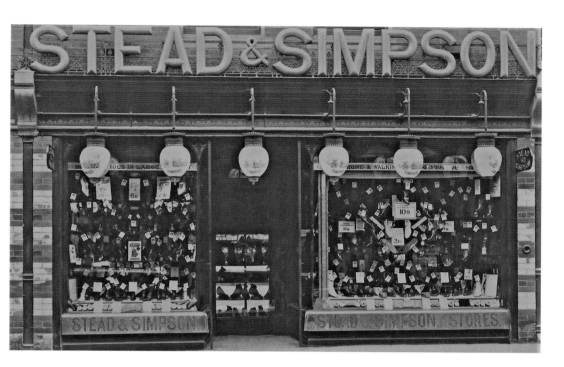

Stead & Simpson, No. 43 Abbeygate Street

This building was rebuilt after the terrible 1882 arson fire which saw much of Abbeygate Street's south side gutted. Founded in 1834 by Edmund Stead and two brothers, Morris and Edward Simpson, Stead & Simpson grew into the largest footwear manufacturer in the world by 1885. Even though they had their own factories in Daventry and Leicester, competition saw these close in 1973. In Bury, the company eventually moved to Nos 19–21 Cornhill but went into administration in January 2008 to be purchased by Shoe Zone. Currently, Scrivens Opticians and Hearing Care Specialists, one of 170 UK locations, are at No. 43.

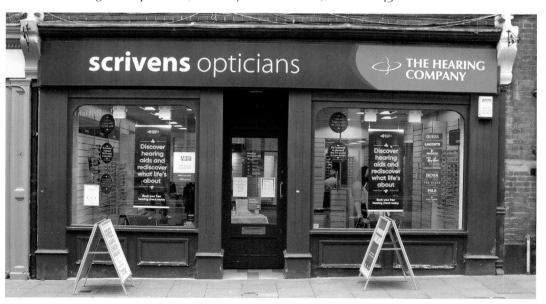

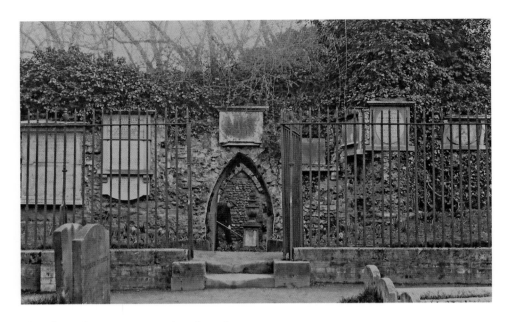

The Charnel House, Great Churchyard

One of only a surviving handful in this country, a charnel house was a consecrated bone depository for exposed skeletal remains. Once two storeys, the chapel was founded by Abbot John de Northwold in 1300. After the dissolution, it became a blacksmith's forge and an inn. Over the years, surrounding gravestones have been removed and plaques put around the perimeter to the unfortunate and the good. Due to its ethereal qualities, it is used for ghost tours. In more recent times, conservation work has been carried out to this building by stonemason Jon 'Elvis' Presley, seen here.

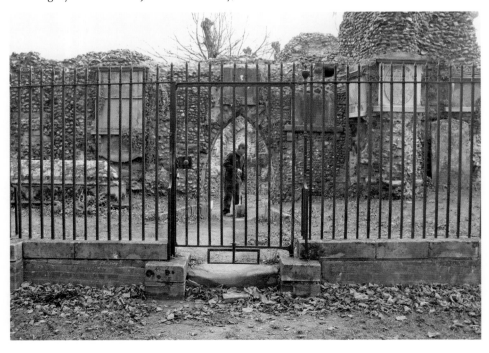

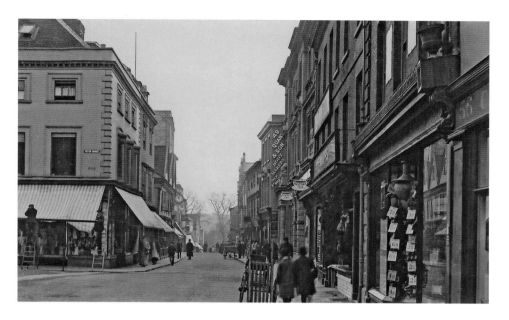

Corner of Abbeygate Street and Buttermarket

Once a common feature on shops in the town, the awning on haberdashers Plumptons is no more. Neither is the business that took over in 1961, Palmers, closing in 2018. On the left, further down the town's oldest business, jewellers Thurlow Champness, closed in July 2022 after 277 years in business. On the right, Quants Shoe Shop (now Shoephoric), at No. 49, was opened in 1879 by Henry Quant and sold Startrite shoes, the first variable width fittings for children's shoes. At No. 55, Days Boot & Shoe Shop displays its prices.

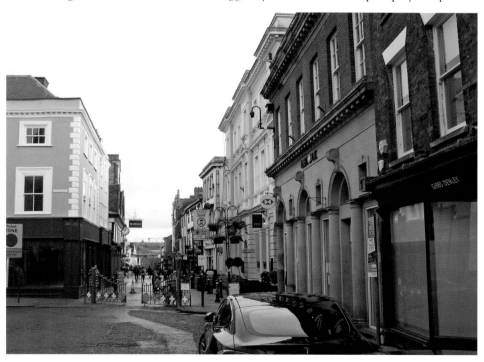

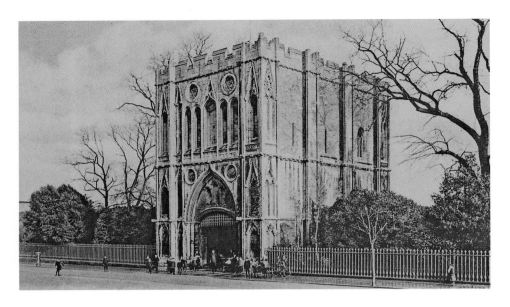

The Abbeygate

The second secular entrance to St Edmund Abbey was rebuilt in the English Decorated style by 1347 first, in Norman style, was destroyed by rioting townspeople in 1327. The abbey's dissolution with the founding of the Church of England by Henry VIII saw statues in the niches removed. The portcullis is a Victorian replacement. After Nathaniel Hodson opened botanical gardens in 1831, railings were later added. They were removed for First World War munitions. The Abbeygate was cleaned just before then, paid for by the Marquess of Bristol.

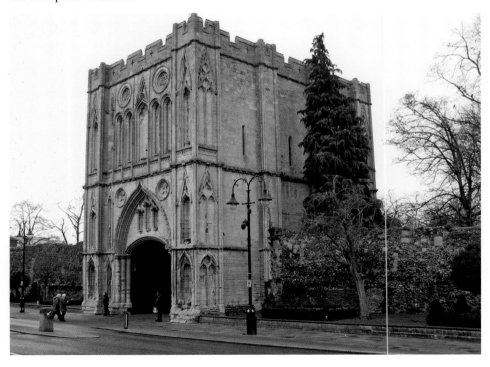